Remembering
Gainesville

Turner Publishing Company
4507 Charlotte Avenue • Suite 100
Nashville, Tennessee 37209
(615) 255-2665

Remembering Gainesville

www.turnerpublishing.com

Library of Congress Control Number: 2010926208

ISBN: 978-1-59652-680-8

Printed in the United States of America

ISBN: 978-1-68336-833-5 (pbk)

10 11 12 13 14 15 16—0 9 8 7 6 5 4 3 2 1

Remembering Gainesville

Steve Rajtar

TURNER

PUBLISHING COMPANY

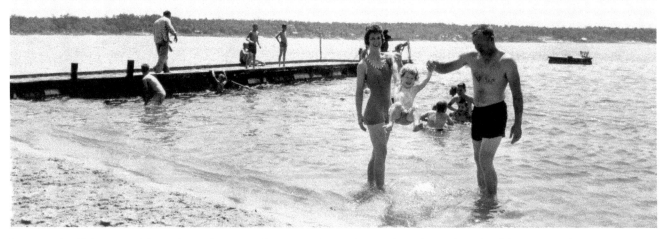

In 1918, the University of Florida's YMCA acquired 20 acres along Lake Wauberg, located south of the campus, for student recreational activities. The land was transferred to the university in 1928 and a recreation center was built in 1939. This photo of a family enjoying a day at the lake, possibly Lake Wauberg, was taken in 1962.

CONTENTS

Gainesville resident Dudley Reed was a master violin maker, and the instruments he crafted during the 1950s are prized by collectors today. He used maple for the back, sides, neck, and scroll, and spruce for the top. The story of his life is recounted in *Dudley Reed, Fiddle Maker: A Memorial* by Howard Reed.

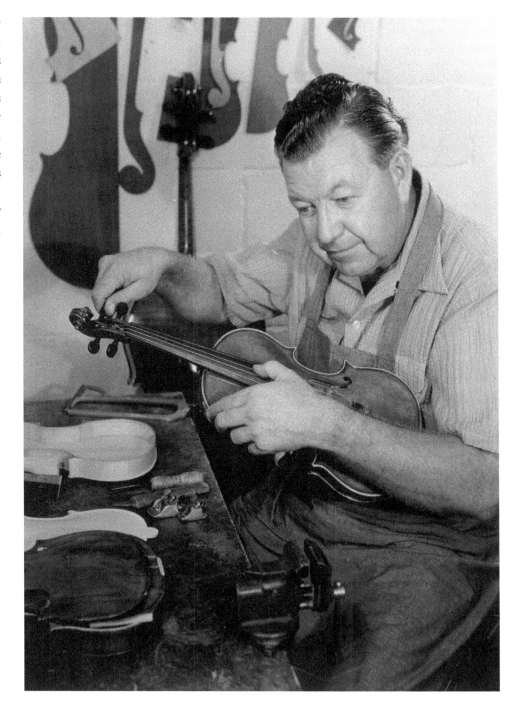

ACKNOWLEDGMENTS

This volume, *Remembering Gainesville,* is the result of the cooperation and efforts of many individuals and organizations. It is with great thanks that we acknowledge the valuable contribution of the Florida State Archives for their generous support.

PREFACE

Today's Gainesville is difficult to imagine without the University of Florida. The campus occupies a large portion of the land near downtown. Nearly every business displays Gator logos, the colors of orange and blue, or other images to cater to students and those who work for the university. One might think that the university came first, and then a town grew up around it.

On the contrary, Gainesville existed long before the university moved to town. The University of Florida traces its roots to 1853, but that date refers to one of its parent institutions, which was located in Ocala. The university moved to Gainesville in 1906, when the town was already a bona fide municipality.

Like most of Florida, the area was settled by individuals engaged in agriculture. Various industries later located there and, unlike much of the state, tourism never assumed a position of primary importance. From the early days, the town has had a broad-ranging reputation for education.

Its schools attracted students from several regions. The Gainesville Academy was founded in 1856 for white students and the Union Academy began a decade later for black students. The educational environment in Gainesville also attracted schools. After the Civil War, the East Florida Seminary arrived and merged with the Gainesville Academy. In 1873, Maggie Tebeau founded a private school with a focus on English and music that lasted for more than 60 years. Chateau-Briant was another well-known institution that helped turn children into well-educated adults.

The biggest coup in the educational field was the merger of several schools to form the University of Florida, and its move to Gainesville. The town was irrevocably changed and now is a world leader in many areas of academia. There is still agriculture, largely as an extension of the university. There is still industry, largely conducted in connection with the university. There is everything an area needs to be a modern city—all connected in some way with the university.

The pages that follow hold images which chronicle more than a century of Gainesville's people, architecture, events, and growth, from its origins as a small distribution center for shipping farm produce to its rise to leadership in research and education.

—*Steve Rajtar*

This project represents many hours of research. The editors and writer have reviewed hundreds of photographs housed in the Florida State Archives. We greatly appreciate the generous assistance of the individuals and organizations listed in the acknowledgments, without whom this project could not have been completed.

The goal in publishing this work is to provide broader access to these extraordinary images, to inspire, furnish perspective, and evoke insight that might assist those who are responsible for determining the future of Gainesville. In addition, we hope that the book will encourage the preservation of the past with adequate respect and reverence.

With the exception of touching up imperfections that have accrued with the passage of time and cropping where necessary, no changes have been made. The focus and clarity of many images are limited to the technology and the ability of the photographer at the time they were recorded.

We encourage readers to reflect as they drive or walk the streets of Gainesville, enjoy the beaches and parks, and experience the amenities of this bustling metropolitan area. It is the publisher's hope that in utilizing this work, longtime residents will learn something new and that new residents will gain a perspective on where the region has been, so that each can contribute effectively to its future.

—*Todd Bottorff, Publisher*

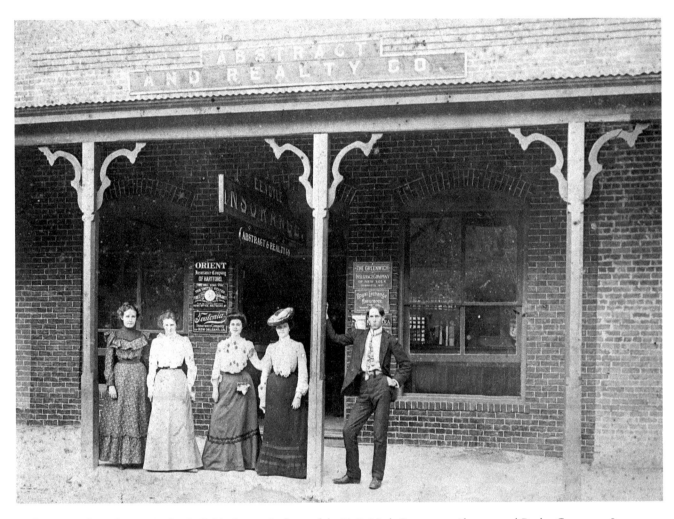

In this image from the 1880s, five individuals pose in front of the E. E. Voyle Insurance, Abstract and Realty Company, In this brick building, Edmund E. Voyle practiced law in addition to selling insurance and preparing real estate abstracts. On his letterhead, he advertised "complete abstract books in this office, and information furnished on all land matters in this county."

EARLY DAYS

(1860s–1899)

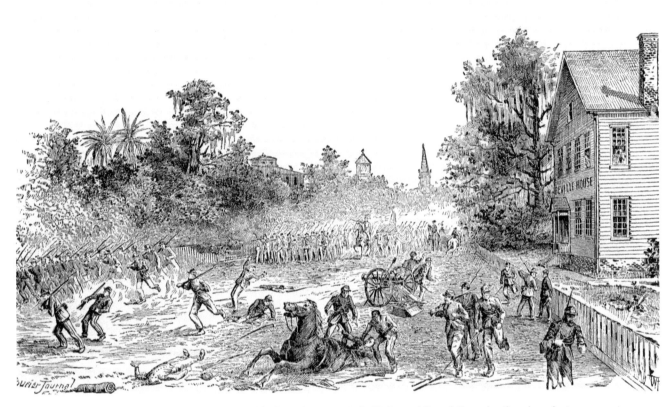

Gainesville had two Civil War encounters in 1864. On February 15, 49 Union soldiers followed railroad tracks into town in an attempt to capture two trains and were met by Confederate Cavalry, which was repulsed. The Union army held the Suwannee Hotel overnight, then departed. Depicted here is the August 17 Second Battle of Gainesville, where many of the 300 Union soldiers were killed or captured by the Florida Cavalry near the depot and the rest were driven away. The Confederates suffered 8 casualties.

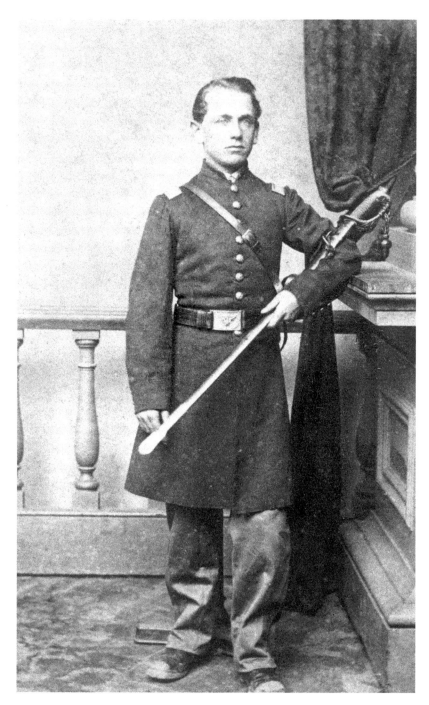

This portrait of Leonard G. Dennis shows him as a young Union lieutenant who fought in the 1864 Battle of Olustee, before he became one of the men who participated in the 1876 ballot stuffing. The first vote count from nearby Archer was 180 for Republican presidential candidate Rutherford B. Hayes and 136 for Democrat Samuel Tilden. After the ballot box spent the night at Dennis' Gainesville home, the count changed to 399 for Hayes and 136 for Tilden. Hayes won Florida by fewer than 1,000 votes and the presidency by a single electoral vote.

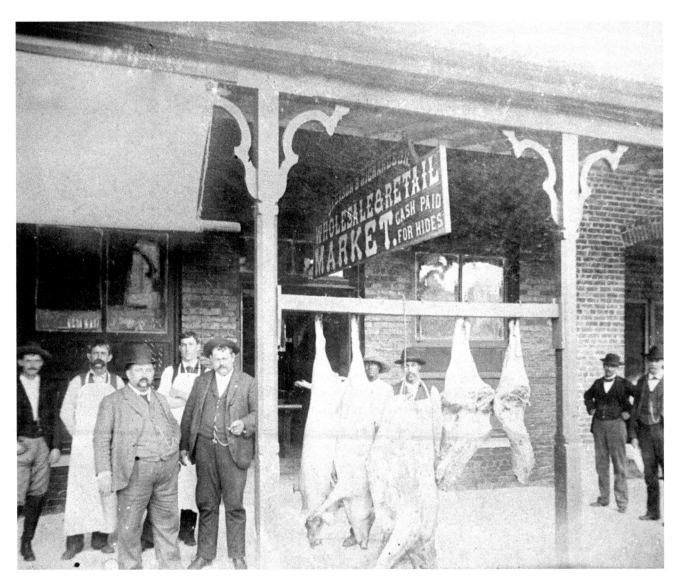

Slaughtered hogs and beef quarters advertise the products sold inside the Jackson and Richardson Wholesale and Retail Market in 1883. One of the owners, the man second from left, is butcher Archie L. Jackson. The business was located on Union Street, now known as SE 1st Avenue. The site was later turner into a parking lot.

W. K. Turner founded the Methodist Society in 1854, which became the First Methodist Church. After holding services in the courthouse and the First Presbyterian Church building, the Methodists built this wooden sanctuary in 1874 along NE 1st Street. It was converted to serve as the congregation's social and lecture hall in 1887, then in 1900 it was moved to 204 NE 3rd Avenue, where it was transformed into a private residence.

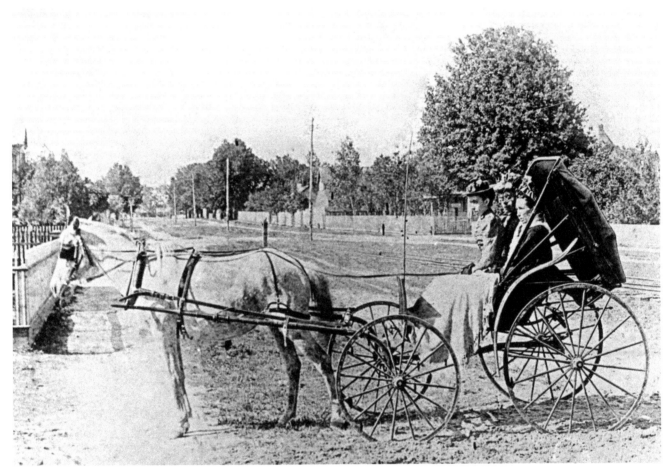

M Giddings was one of Gainesville's first professional photographers. He captured this image of his family sitting in a convertible buggy with the top pushed back to take advantage of the sunshine. Mrs. Giddings and their daughters, Minnie and Asher, are dressed in their Sunday best. A close look behind them northward on North Main Street reveals that the early electric lines were hung in the middle of the street, and the railroad tracks were three in parallel to accommodate both narrow and standard-gauge trains.

In 1853, the decision was made to move the county seat from Newnansville, and the following year Gainesville's Courthouse Square was planned with the rest of the town surrounding it. On the square, this two-story wooden structure was built at a cost of $5,000 to serve as the city's first courthouse. It was utilized until 1884, not only for governmental functions, but also for social activities and religious gatherings. The fence was erected around it to prevent cows and other animals from disturbing court proceedings.

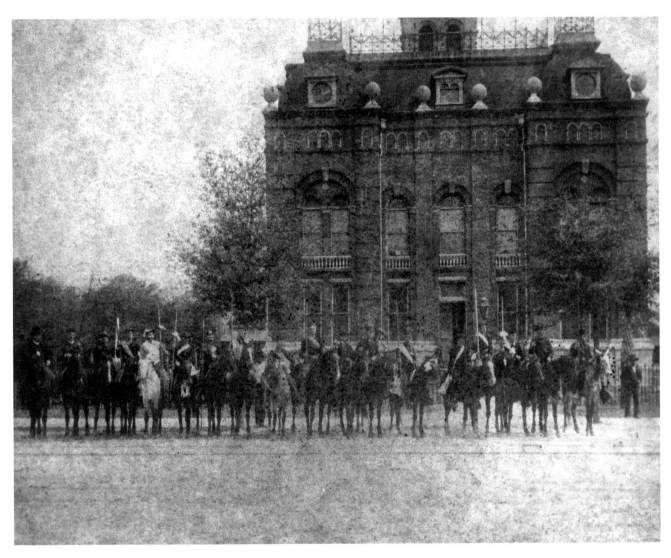

In the mid-1880s, a home guard of the state militia formed in Gainesville. Members are shown here in front of the newly completed Alachua County Courthouse. One of the motives for organizing the guard may have been an arsonist, who in 1884 set fire to the Varnum and Arlington hotels, and attempted to burn down a livery stable. Afterward, the guard and East Florida Seminary cadets patrolled the town at night. The guard also served as a social club and community service organization.

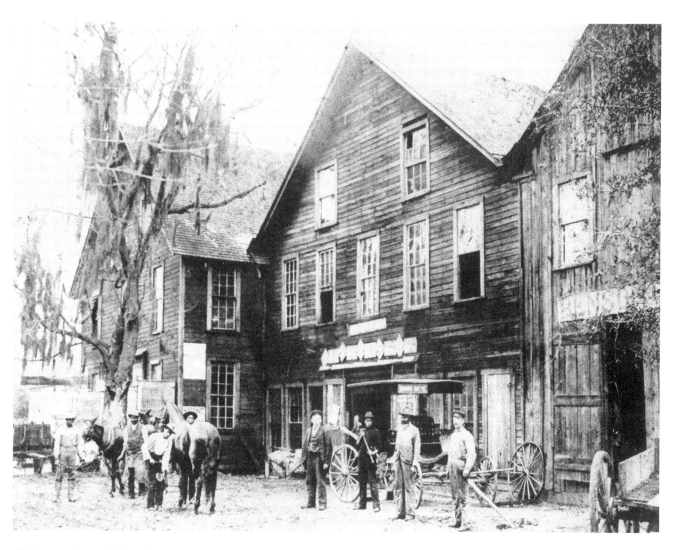

To the southeast of Courthouse Square in the 1890s were more businesses, dealing mainly in horses and the care of horses. Shown here is Benson's Livery and a blacksmith shop next door, where Gainesville residents could have their wagons and buggies repaired. Farriers shoed horses and otherwise cared for them here, and the livery offered boarding. These buildings were located on SE 1st Avenue, approximately where today's modern post office stands.

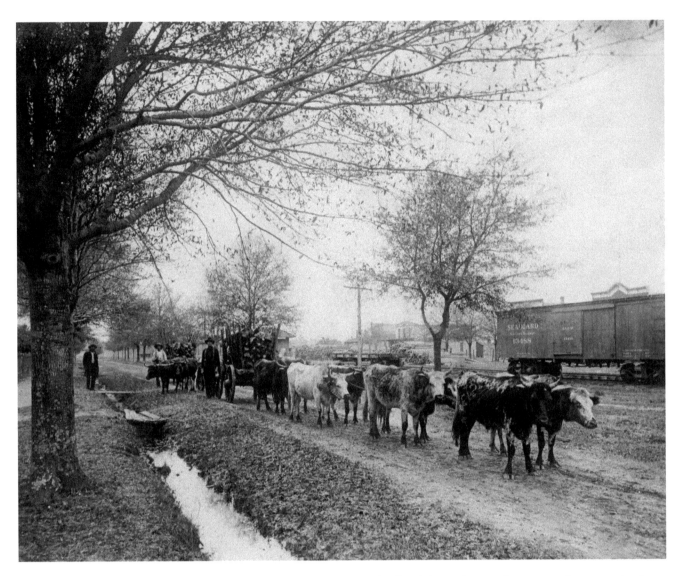

About half a mile south of Courthouse Square stood Gainesville's original railroad depot. During the nineteenth century the depot and the area surrounding were busy with commercial activity. It was replaced in 1907 with another depot just off South Main Street, a road that carried a variety of vehicles, especially those for hauling crops and products to and from the depot. Shown here in the 1890s are teams of oxen pulling logs, sharing the lanes with freight trains as well as horses and buggies.

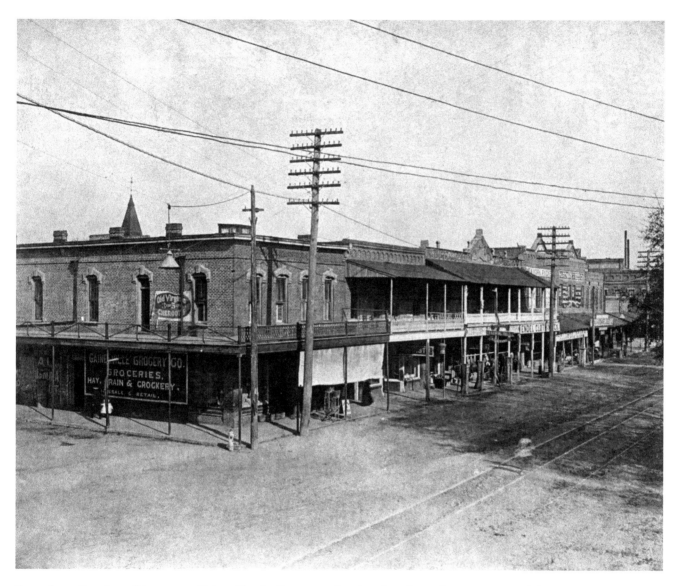

From the earliest days of downtown Gainesville, the four streets forming Courthouse Square constituted the main business district. Shown here in the 1890s is South Main Street, along the west side of the Square. At 126 South Main Street, the New York Racket Store advertised itself as the "Cheapest Store on Earth." At the Thomas Company store, one could buy farm equipment, furniture, and garden tools. Other stores on the block included the Gainesville Grocery and Endel Clothing.

Pictured here are several women, a girl, and a dog, at the home of attorney John A. Ammons at the corner of North East Main and Mechanic streets (now known as NE 1st Street and 1st Avenue). Those pictured likely include his wife, the former Kate Phillips of Mississippi, and their daughter, Mary. Next door resided Kate's parents, Dr. and Mrs. Newton D. Phillips.

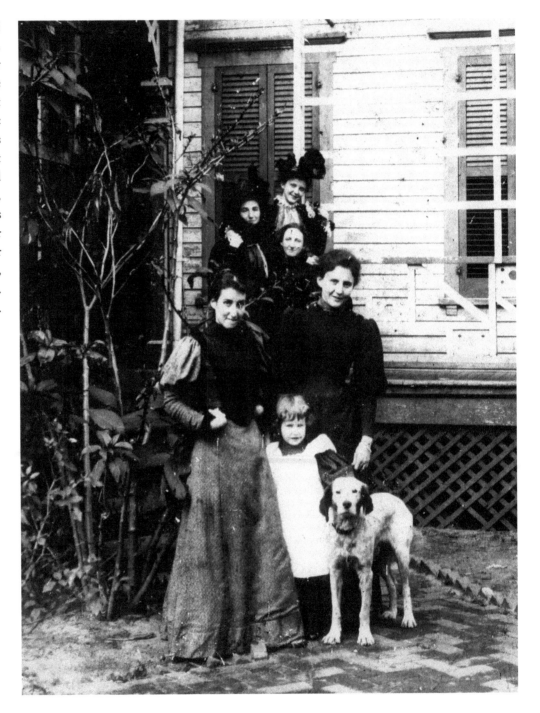

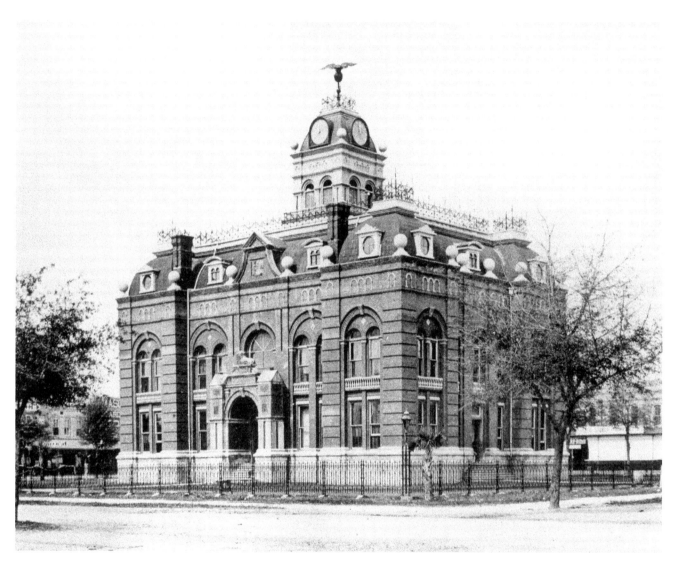

As Alachua County grew, it was decided to replace the original wooden courthouse with this red brick building, which cost $50,000. Dominating Courthouse Square, the structure featured a clock tower crowned with a flying eagle. The building's original mansard roof was replaced in later years after leaks appeared, and the eagle was also removed. The iron fence was erected to keep out pigs, dogs, and chickens, which roamed free on the square.

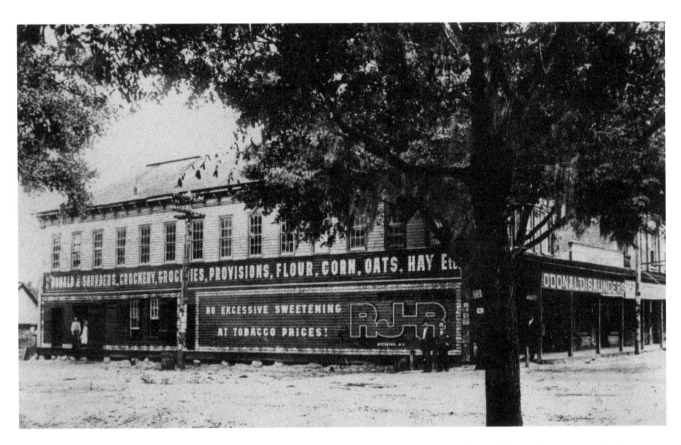

At the southeast corner of Alachua Avenue and SE 1st Street stood the grocery store of Phillip Miller and Company, which was acquired by Edward O'Donald and Minot Bacon Saunders during the 1880s. As the O'Donald and Saunders Grocery, it was one of the largest grocery stores in the region and also sold hay, grain, glassware, tubs, tiling, and other items, including Columbia and Hartford bicycles.

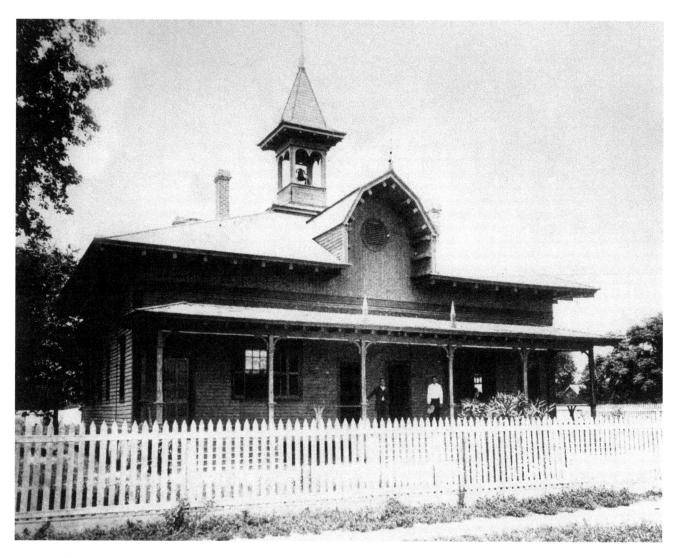

The federal Freedmen's Bureau founded the Union Academy in Gainesville with the goal of educating former slaves and their families. It opened in this building in January of 1866 with an enrollment of 175, which grew to about 500 by the turn of the century. The school was located at 612-620 NW 1st Street and was run by a board of local black leaders. Financial help came from the George Peabody Fund and the first classes were taught by white teachers from the North, later joined by local black teachers.

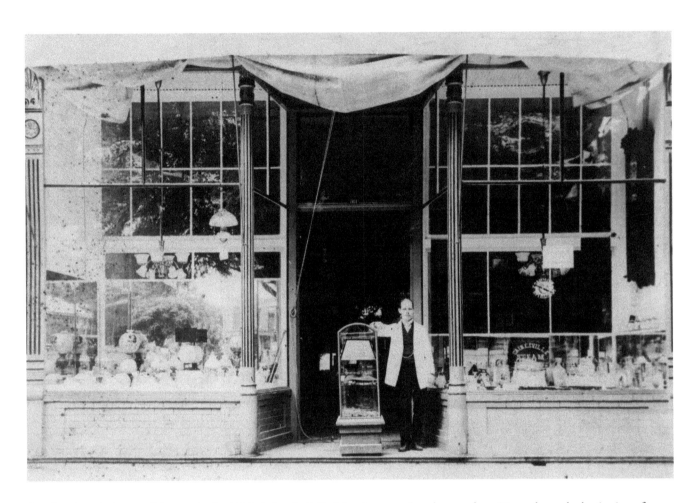

Standing here in front of his store in the 1890s is Lewis C. Smith, who moved to the area from Kentucky at the beginning of the decade. In addition to rings and watches and necklaces, the L. C. Smith Jewelry Store just south of Courthouse Square sold silverware, cut glass, shoes, and hosiery. In the rear of the building was his L. C. Smith's Print Shop, where he handled commercial printing jobs.

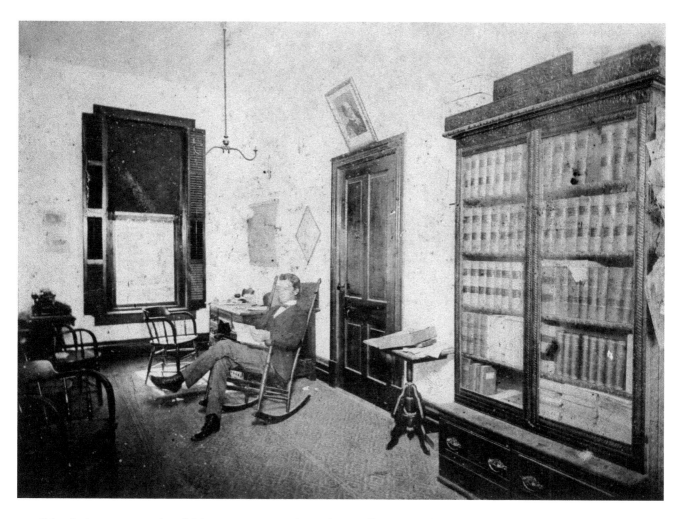

John A. Ammons, a native of Arkansas, was a prominent Gainesville attorney during the 1890s. He and his family lived at the corner of NE 1st Street and 1st Avenue, next door to his wife's father and perhaps a stepmother. John is shown here in his law office, also located on NE 1st Street.

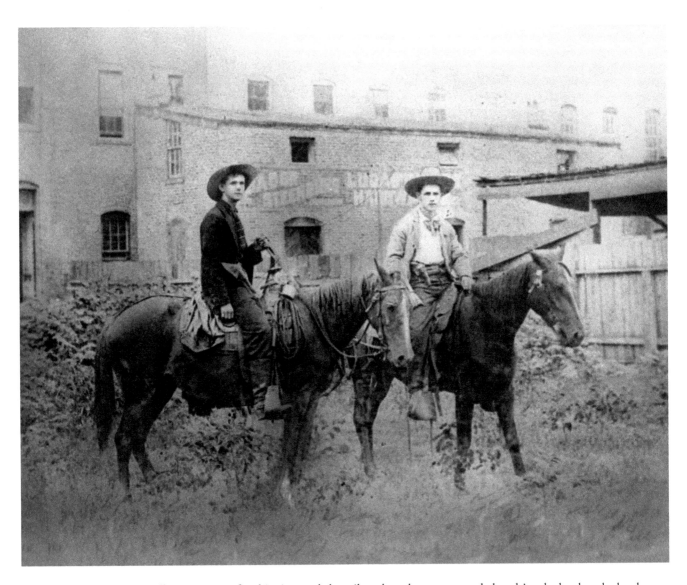

During the 1890s, Gainesville was a center for shipping cattle by rail, and cowboys were needed to drive the herd to the local cattle pens. Many of the animals roamed wild and were descended from old Spanish herds. Here, Archer Jackson and Thomas McDonald are shown after driving about 50 head from Old Town in Dixie County across the Suwannee River to bring them to the cattle yards near the Steenberg Hardware & Leather Company just west of Courthouse Square.

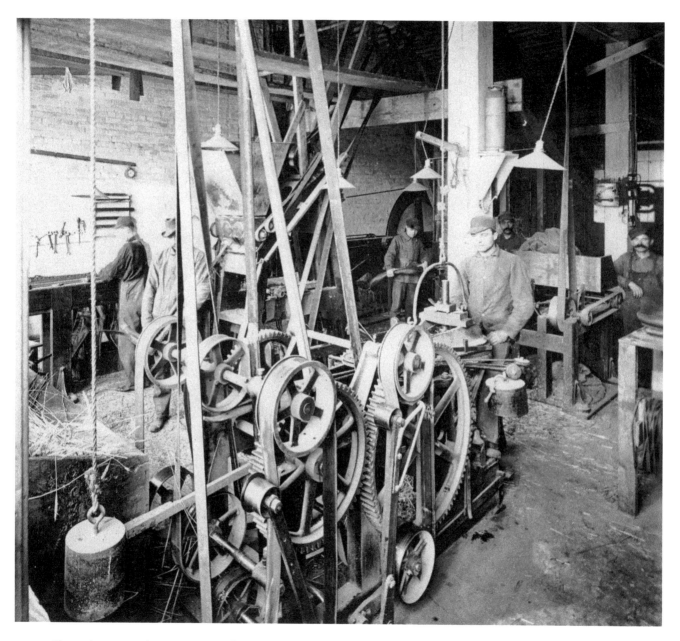

Shown here around 1899 was one of Gainesville's industries related to both agriculture and transportation. Utilizing steam-powered machines, this factory manufactured leather horse collars.

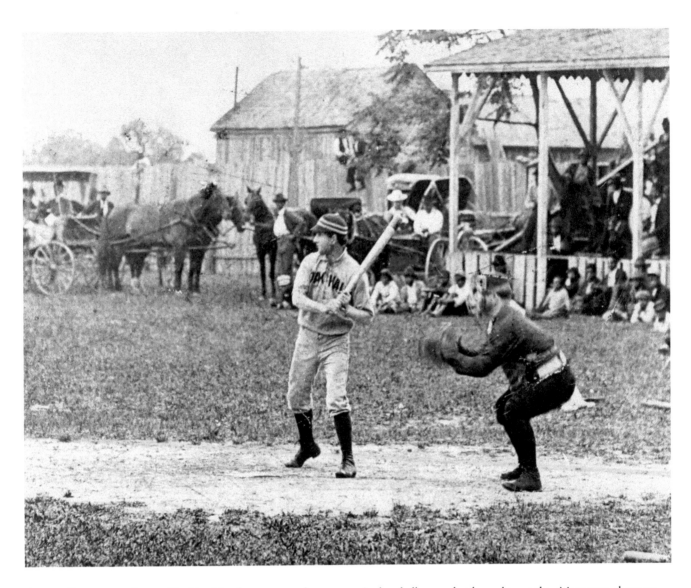

Gainesville was one of many Florida cities that supported a community baseball team that brought out the citizenry to cheer on the hometown boys. A baseball diamond had been set up in a field near Tillman Ingram's home, which he named Oak Hall, so the team was called the Oak Halls. Shown here near the end of the nineteenth century is an Oak Hall batter and fans sitting in a small grandstand, on the ground, and in their horse-drawn vehicles parked in foul territory.

20

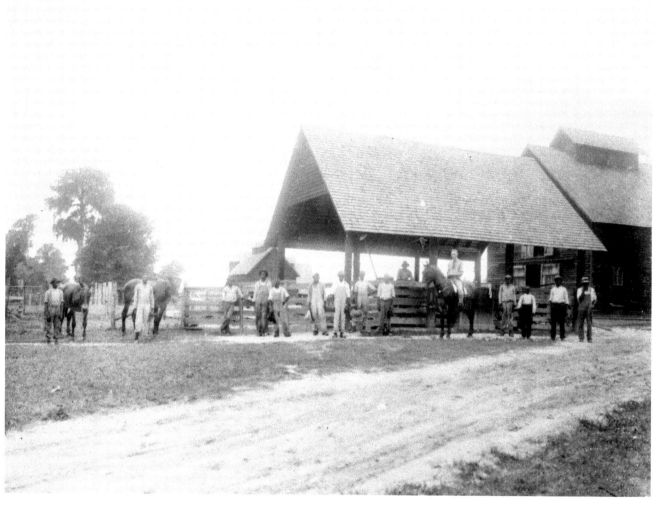

Nineteenth-century Gainesville had several livery stables, blacksmith shops, and related businesses to keep its residents' wagons and buggies and plows moving. Some were located close to Courthouse Square and eastward to Sweetwater Branch, although the one depicted here appears to be well removed from the central business district.

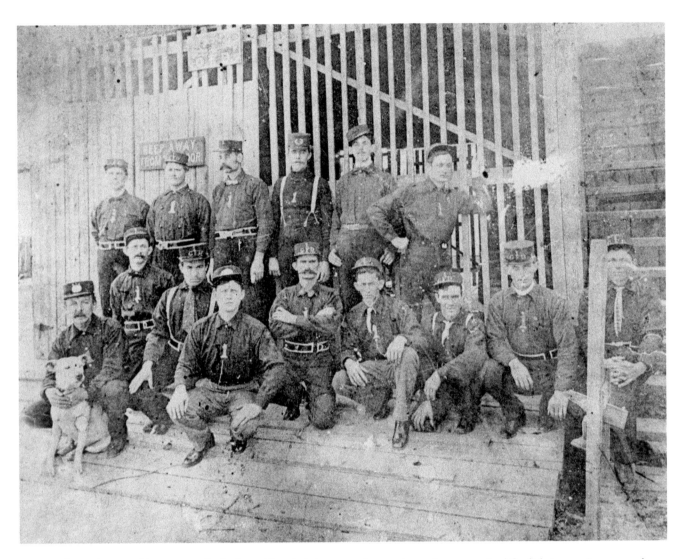

Gainesville residents and businesses, tired of watching their homes and stores burn down, acquired firefighting equipment and formed the city's first volunteer fire department in 1882. The first pumper engine was provided by Leonard G. Dennis and was operated by these men, the volunteers of Hose Company No. 1. Their fire station was located southeast of Courthouse Square. Despite the effort, fires continued to exact heavy tolls on the community when they broke out.

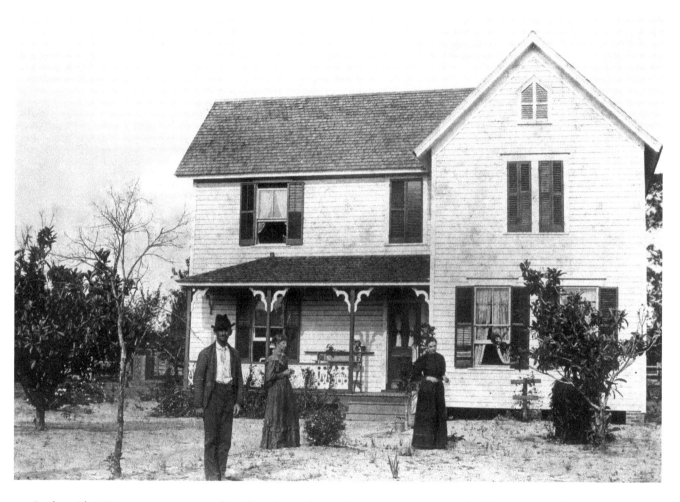

In the mid-1890s, commerce centered on Courthouse Square, but not everyone wanted to live close to the hustle and bustle of downtown. J. D. Turner was one such person, and when he built this home, he chose a location far out in the country. With today's numbering system, the lot would have had an address of approximately 2100 NW 8th Court. Mrs. Turner is shown here, flanked by Mr. and Mrs. B. Wells, in front of the simple L-plan home built on piers to provide cooling summer ventilation.

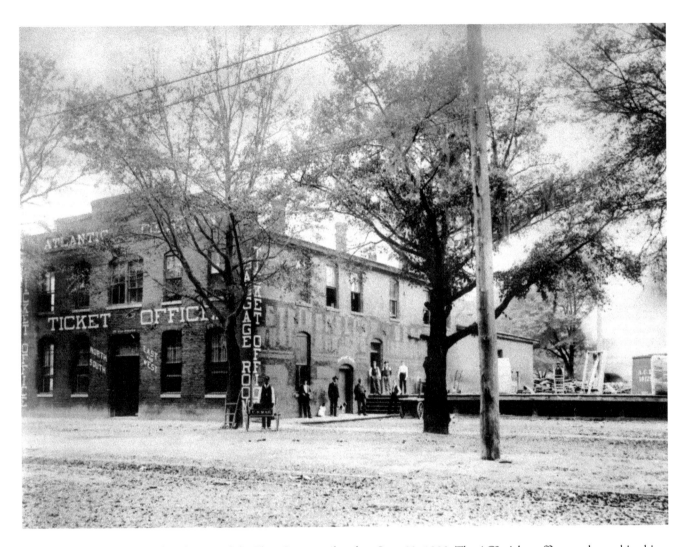

The Atlantic Coast Line Railroad acquired the Plant System railroad on June 30, 1902. The ACL ticket office was located in this building on Main Street, standing on the west side between 1st and 2nd avenues. After it ceased being used for railroad ticket sales, the two-story brick structure was sold in 1946 to John Camp, who had relocated to Gainesville from Ocala. In 1953-54, the building was razed and replaced with a new home for the First National Bank.

Becoming a College Town

(1900–1919)

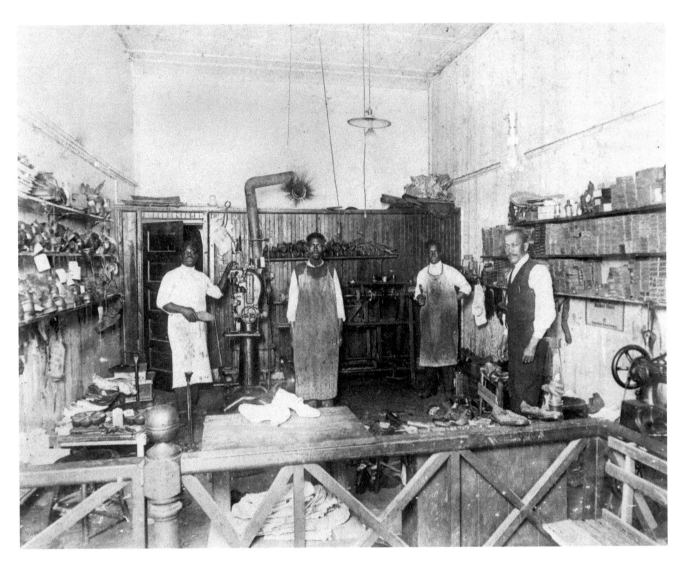

The area around early Courthouse Square included both white-owned and black-owned businesses, reflecting the population mix of the city. One of the best-known black enterprises was the Duval Shoe Hospital, which stood at the northwest corner of SE 3rd Street and 1st Avenue. When this photograph was taken, around 1900, the address was 216 Union Street. The man on the right is probably Mr. Duval. White and black residents brought their shoes to him to be repaired.

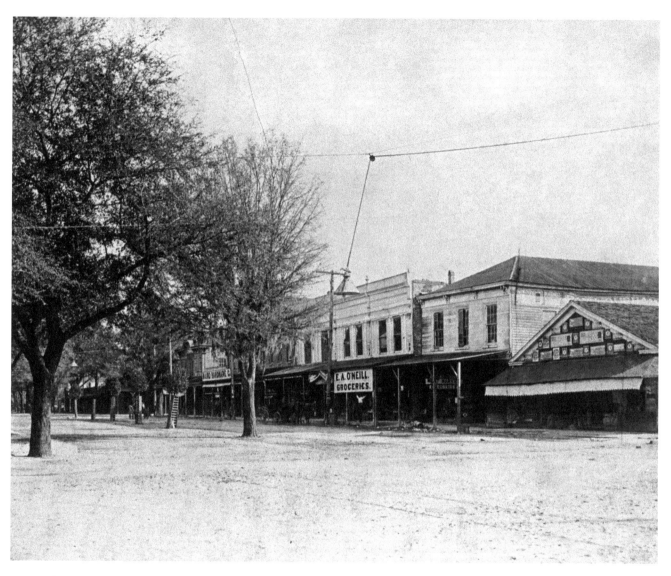

By the end of the nineteenth century, most of the wooden buildings on the west side of Courthouse Square had been damaged by fire and replaced with brick structures. About half of those on the east side were still made of wood, including the one-story Harrold Meat Market and Grocery at right. Next door was the two-story wooden Harrold annex, with the E. A. O'Neill Grocery Store next door to the north. Beyond that were J. N. Vidal Groceries and Baird Hardware.

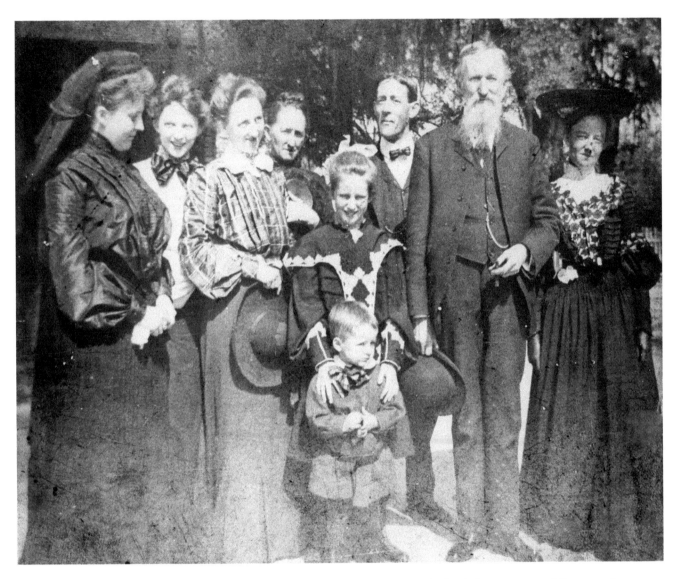

Among several Gainesville residents is Dr. Newton D. Phillips, who professed that the local climate was good for most ailments, despite its lack of a waterfall or fast river to cleanse and purify the drinking water. One of the city's earliest doctors, it is believed that he was the father of the woman at left, Kate Phillips Ammons. She is dressed in traditional mourning clothing, which indicates that this is 1903, the year of the death of her husband John.

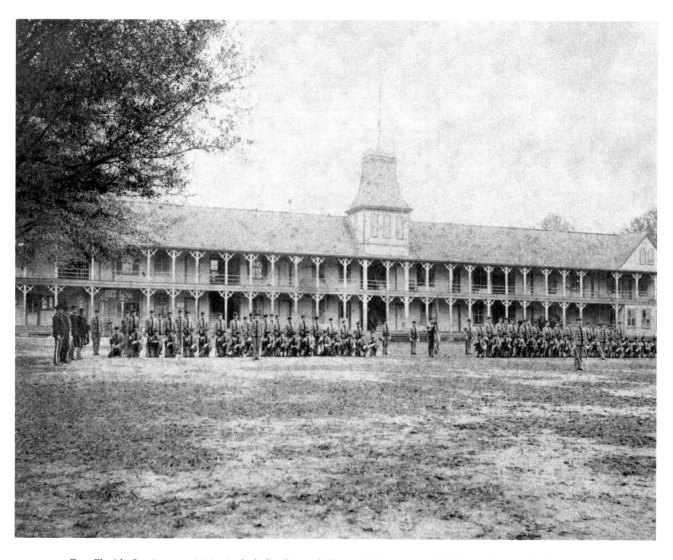

East Florida Seminary activities included military drills on the large open field shown here, today known as Roper Park. At the north end of the drill field stood this wooden structure, 197 feet long and 90 feet wide. It served as the dormitory for male students and faculty members, who slept on mattresses stuffed with Spanish moss and supported by iron frames. It is shown here as it appeared in 1903, eight years before it burned down. A separate building included the bathrooms, a kitchen, and an infirmary.

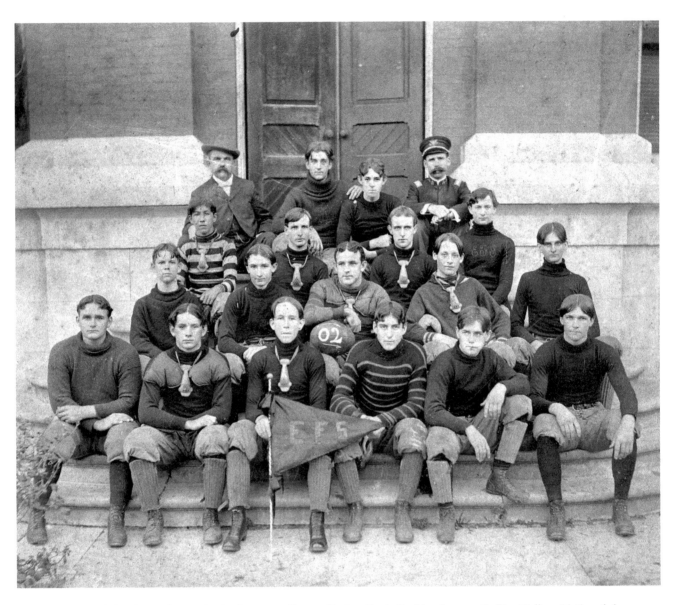

The University of Florida marks 1906 as its first year of intercollegiate football with wins over Rollins College (6-0) and the Riverside Athletic Club of Jacksonville (19-0), and a loss to Savannah (27-2). Prior to 1906, however, two of the university's parent institutions played ball. Florida Agricultural College lost its first game in 1901 to Stetson University (6-0) and lost the 1902 rematch (6-5). East Florida Seminary also had a team, shown here in 1902.

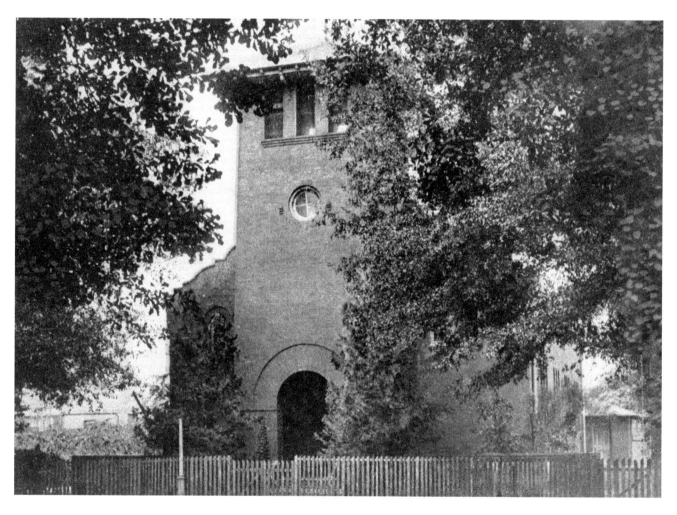

Catholic masses in Gainesville began in 1862 and were held in the home of James Battle, city hall, the Flynn home, and Young's boardinghouse. In 1887, the first sanctuary of St. Patrick's Catholic Church, shown here, was built at 806 NE 1st Street. Two pieces of the building, the 1887 cornerstone and an elaborate frieze, were removed before the building was demolished and are now on display outside the front door of today's sanctuary, which opened in 1976 at 430 NE 16th Avenue.

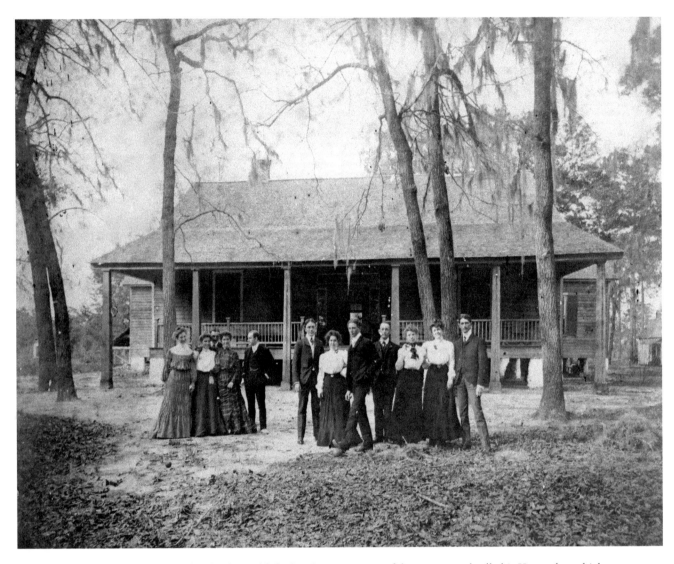

In 1854, Thomas Evans Haile and his family established a plantation west of downtown and called it Kanapaha, which may have come from Timucuan words for "palmetto leaves" and "house." Their slaves constructed a 6,200-square-foot house in 1856 near the projected route of David Yulee's railroad running from Fernandina to Cedar Key. The trains which ran adjacent to the plantation made it easy to ship crops to market, and to visit friends, pick up mail, and shop for supplies in Gainesville.

The Tebeau School was originally located just north of Courthouse Square, then moved to this building on a lot shaded by water oaks, occupying an entire city block two streets south of the square. Young ladies and gentlemen received a quality education in a setting which included large gardens and athletic facilities. In 1909, it became the official diocesan school for girls for the Episcopal Church. Classes ended in 1936, 12 years after the death of Maggie Tebeau. The school was torn down in 1951.

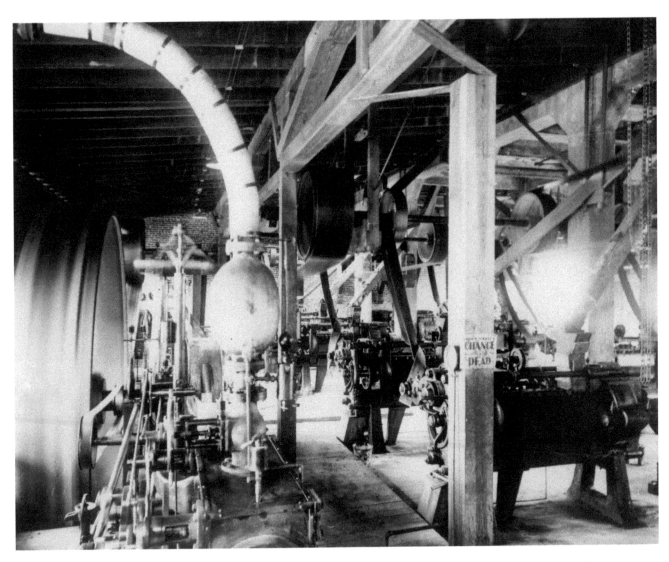

In 1887, the Gainesville Electric & Gas Company was formed by F. W. Cole, James Graham, and H. E. Taylor. Under a city franchise, the company provided electricity and natural gas to homes, provided two lights on Courthouse Square, and illuminated the city clock each evening until midnight. Shown here is the interior of the early powerhouse for the city. The sign on the post says, "Don't take a chance, you will be a long time dead."

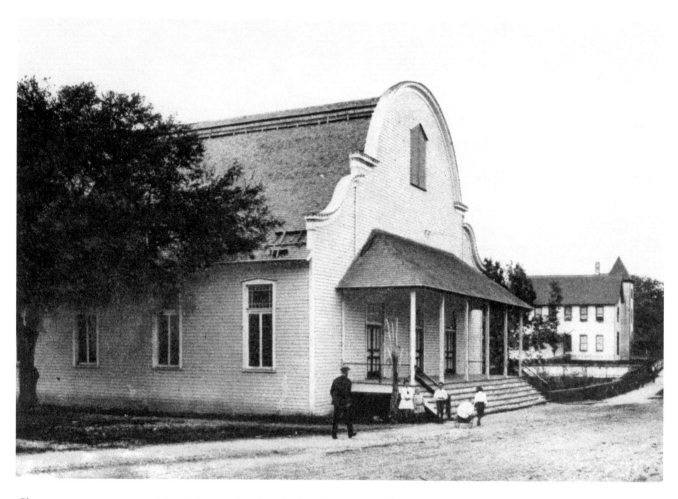

Chautauqua, a movement with religious, cultural, and educational aspects, began in Chautauqua, New York, and spread across the country. In the early 1900s, traveling bands of lecturers presented programs to assemblies, often in large tents. Many towns of all sizes erected permanent auditoriums to house the Chautauqua programs and other large assemblies. Shown here is the Gainesville Chautauqua Tabernacle, also known as the Chautauqua Church, which stood at 567 East University Avenue.

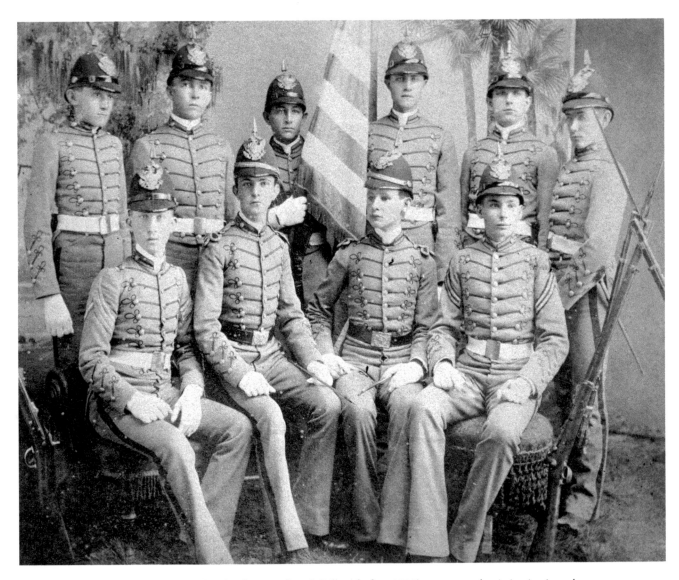

Although the University of Florida (the Florida Agricultural College before 1903) was an academic institution, there was a strong military influence. A group of cadets poses here for a portrait in the dress uniforms they wore about the time the school moved from Lake City to Gainesville in 1906.

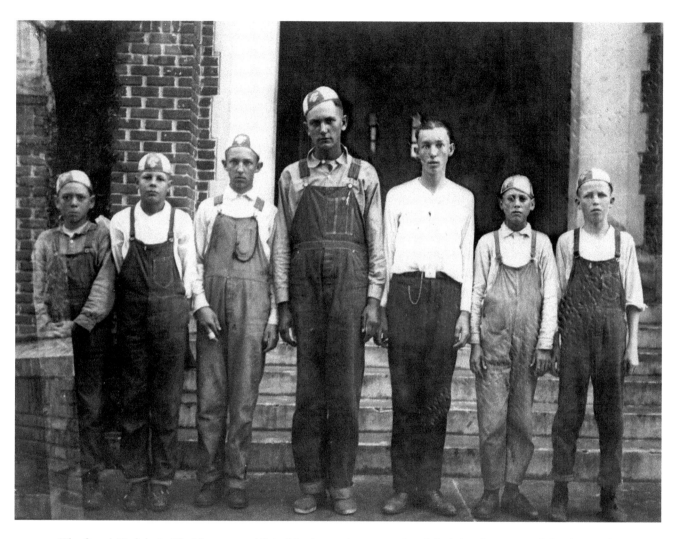

The first 4-H clubs in Florida were established in the northern counties of Gadsden, Suwannee, Columbia, and Madison. They were affiliated with three state-supported schools, with white girls learning home economics from agents at the Florida State College for Women, now known as Florida State University. Black children worked with agents housed at Florida A & M University. The University of Florida taught agricultural methods to white boys, such as this group from Gadsden County in the 1910s.

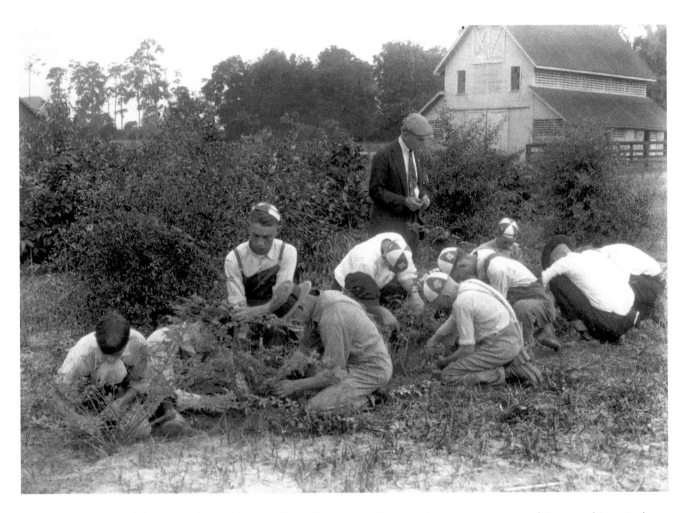

During the 1910s, the University of Florida began offering "short course" instruction on campus to youth interested in agriculture. Classes could be held during the summer, leaving dormitory space available for students to live on campus for a number of weeks and experience farming with the latest available equipment and techniques. Shown here is a group of boys learning how to bud.

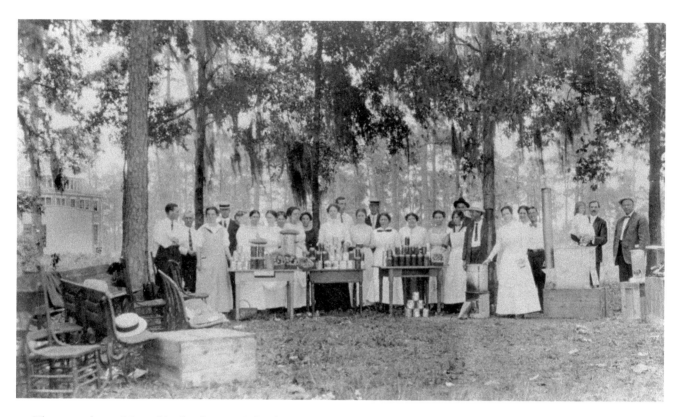

These people participated in the Canning School, a series of seminars on health and food preparation held at the campus of the University of Florida on January 9-11, 1912. The university has had a strong background in agriculture and home economics since before it moved to Gainesville, with the establishment of its predecessor Florida Agricultural College in 1884 in Lake City.

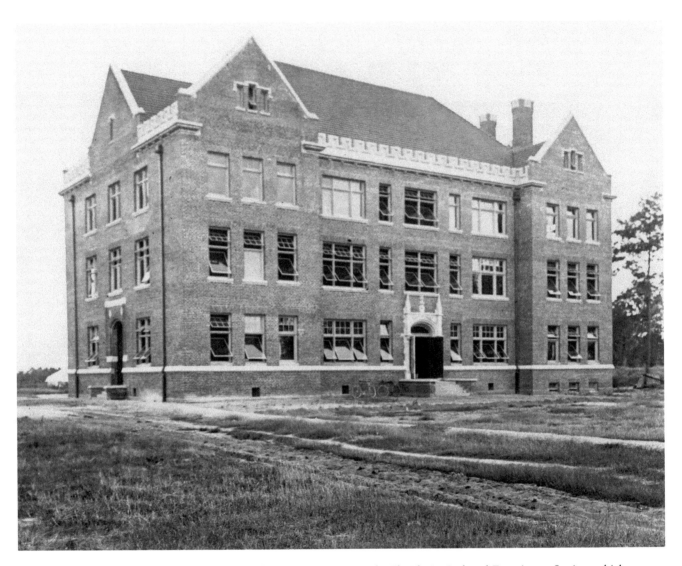

An important part of the Florida Agricultural College in Lake City was the Florida Agricultural Experiment Station, which moved to Gainesville with the rest of the school in 1906. Initially, agricultural experiments were conducted in Thomas Hall, but that building was soon outgrown. Pictured here in October 1910 is the new home of the Experiment Station, constructed in 1909-10 along the west side of Buckman Drive at the University of Florida. It was designed by William Edwards.

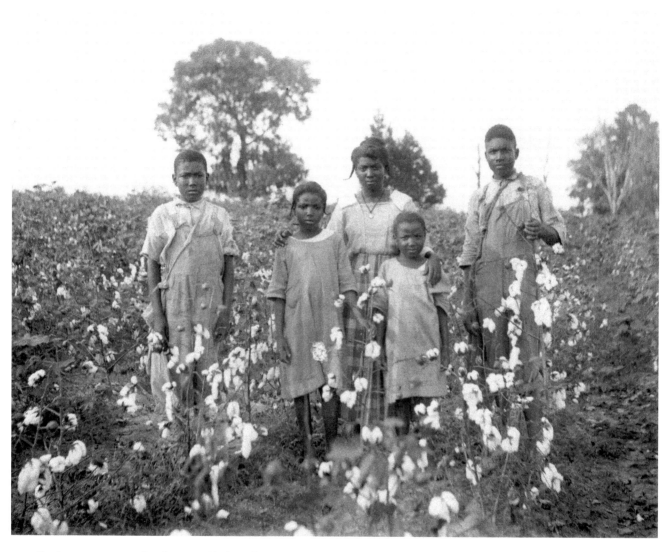

Settlers were attracted early on to Alachua County to raise cotton. During the late 1850s, settlers from South Carolina helped make Gainesville strongly pro-secession, believing that the success of their plantations depended on the preservation of slavery. Following abolition, cotton's importance to the local economy diminished, but in the 1880s Gainesville remained Florida's largest producer and shipper of sea-island cotton. Shown here is a family still involved in growing cotton about 1910.

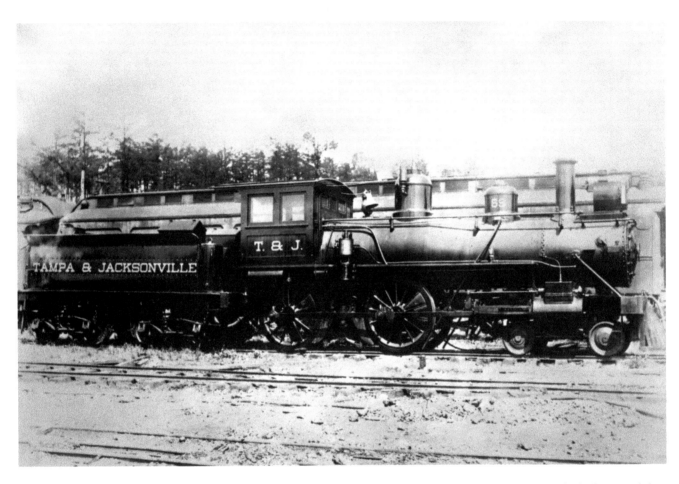

In 1913, this steam locomotive was designated Number 59 of the Tampa & Jacksonville Railway Company, which also served the nearby town of Micanopy. In 1927, the line became the Jacksonville, Gainesville & Gulf Railroad, and quickly became part of the Seaboard Air Line. Before becoming a part of the T&J, this engine was known as Number 16 of the Birmingham & Atlanta Railroad and as Number 851 of the Southern Iron and Equipment Company of Atlanta.

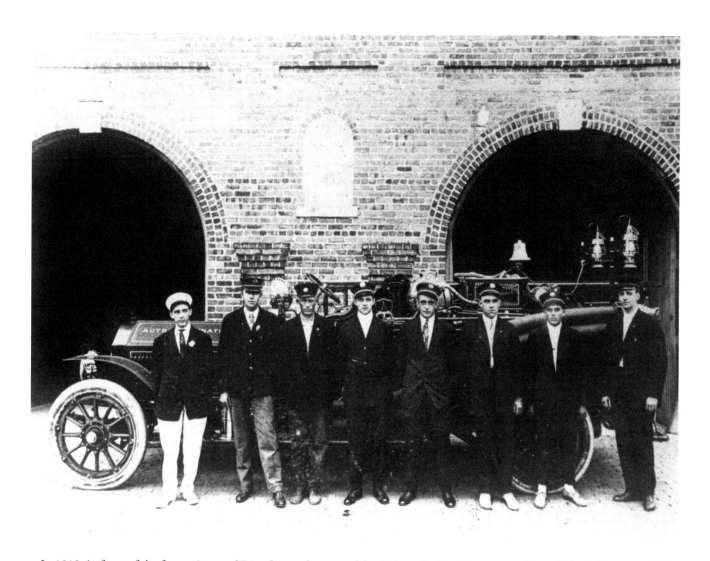

In 1912, in front of the fire station on SE 1st Street, the men of the Gainesville Fire Department show off their shiny new ladder and pumper truck. It was a great leap forward from the days when a fire alarm meant that volunteers had to be summoned from their homes or jobs, the horse had to be harnessed to the wagon, and the equipment had to be pulled over unpaved roads to reach the scene. The two professionals serving in the firehouse here could now drive to it.

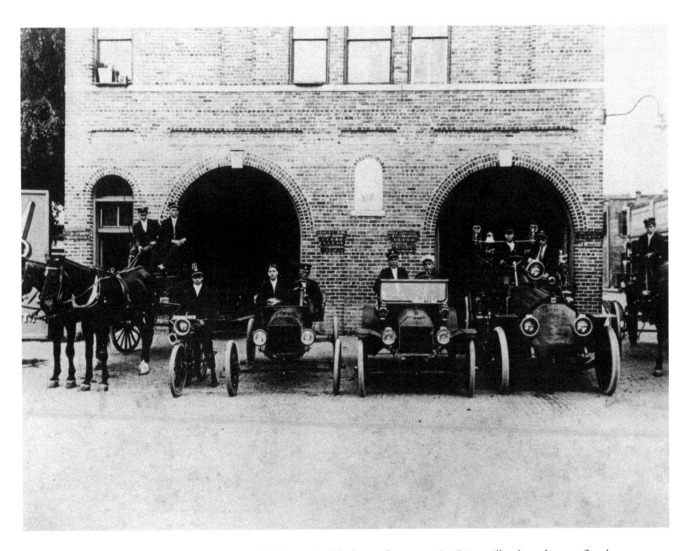

The introduction of motorized fire engines signaled the end of the horse-drawn era. In Gainesville, the volunteer fire department got its first horse, named John after the department's chief John MacArthur, about eight years after getting its first wagon. When John (the horse) wasn't pulling the fire wagon, he was hauling away garbage. The next two horses were named Mac and Arthur, also after the chief. This 1912 photograph shows the horses being retired from service.

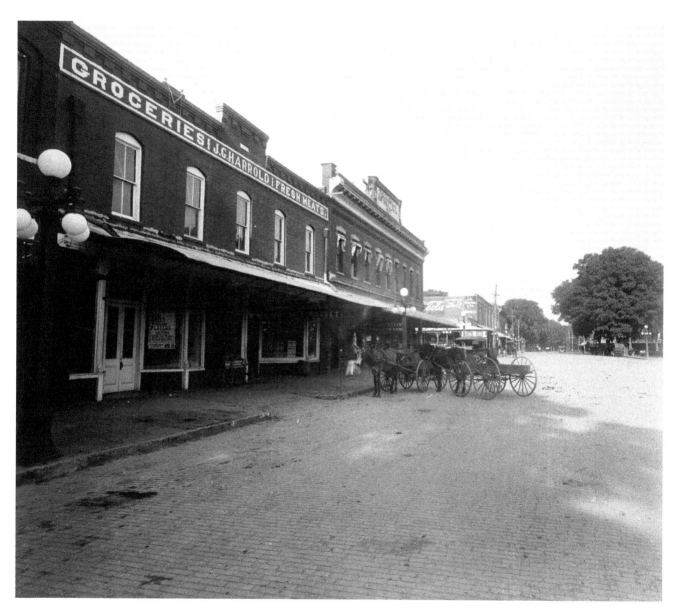

Still in business after at least 15 years, J. G. Harrold sold fresh meats and groceries in 1914 here, on the east side of Courthouse Square at the corner of Union Street (SE 1st Avenue). Harrold's business started out in a one-story wooden building, expanded to include a two-story wooden annex next door, and continued growing to take on this more substantial appearance.

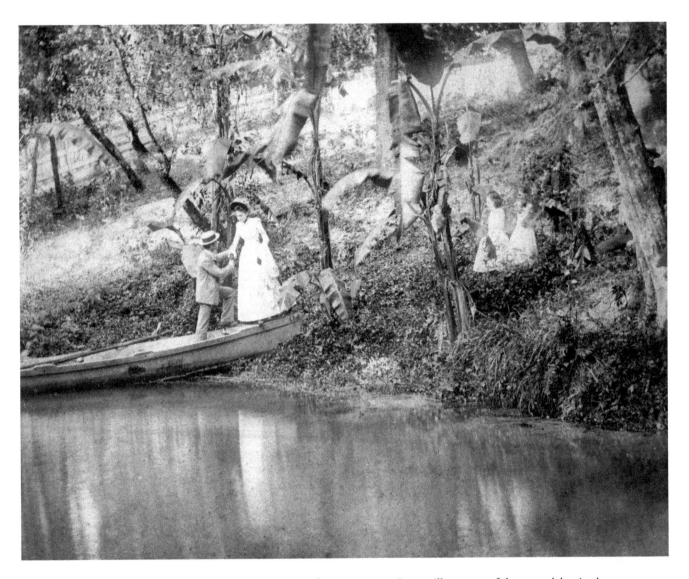

This is an early image of a man helping a woman into a rowboat in or near Gainesville, at one of the many lakes in the area, possibly Newnan's Lake located off SR 20 east of downtown. Named for Colonel Daniel Newnan who fought the Seminoles there in 1812, the lake remains popular for all kinds of boating, including rowing (usually in sculls instead of rowboats). Gainesville Area Rowing puts on rowing classes and regattas, including the popular Gator Head Regatta each autumn.

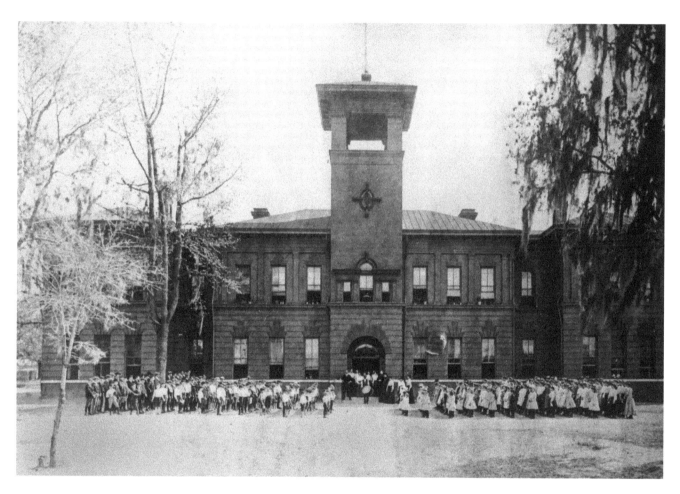

The Gainesville Graded and High School was constructed at 620 East University Avenue during 1900 at a cost of $30,000. It was renamed the Kirby Smith School to honor St. Augustine resident Edmund Kirby Smith (sometimes written Kirby-Smith), the last Confederate general to surrender, more than six weeks after Robert E. Lee did. The school opened with 12 classrooms, an office for the principal, and a large auditorium. Initially, the student body consisted of children of elementary and junior high ages.

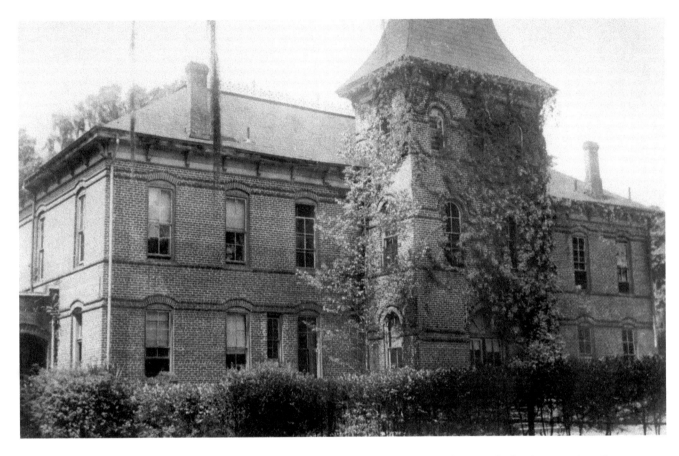

The first East Florida Seminary building burned down in 1883 and was replaced with this one, the brick Epworth Hall. Originally, the main entrance was through the tower facing south, and inside were classrooms and the school's administrative offices. After the seminary merged into the University of Florida, the university's first classes were held in Epworth Hall. Five years later, the building was sold to the First Methodist Church, which moved its main entrance to the west end of the building facing NE 1st Street.

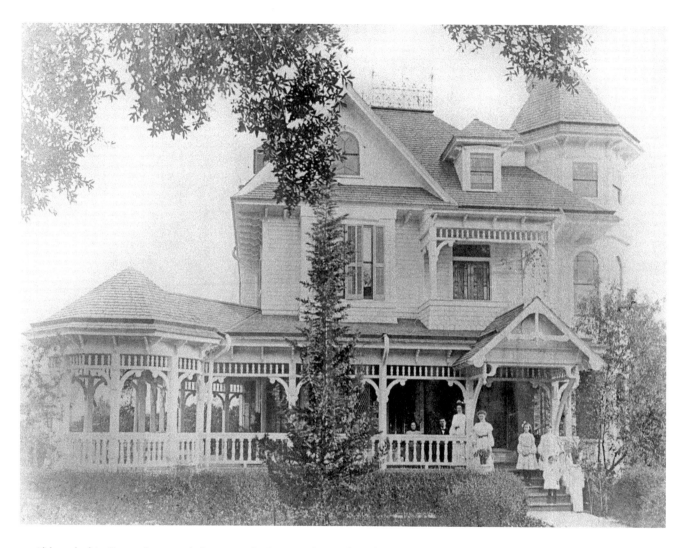

Although this Queen Anne–style home was built around 1895 by John Lambeth, it is known as the McKenzie House for motor company owner Reed McKenzie and his wife, Mary Phifer McKenzie, who bought it in 1925. It retains its original appearance with a widow's watch room in the three-story polygonal tower and an attached single-story gazebo. The horizontal wood siding and projecting gable over the main entrance have been well maintained. In 1980 the structure was converted to offices.

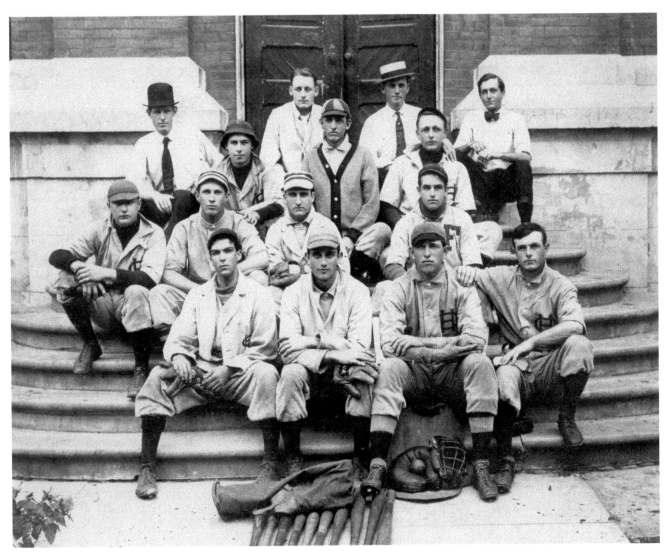

With the appearance of the university and its sports program, baseball remained popular. Professional teams visited Gainesville and other small towns in the spring while their home fields north were buried under snow. Gainesville attracted the New York Giants for their 1919 spring training, partly because they were offered the use of a new building on campus, later turned into the Women's Gymnasium. The city band and dignitaries greeted the Giants, who received the key to the city from the mayor.

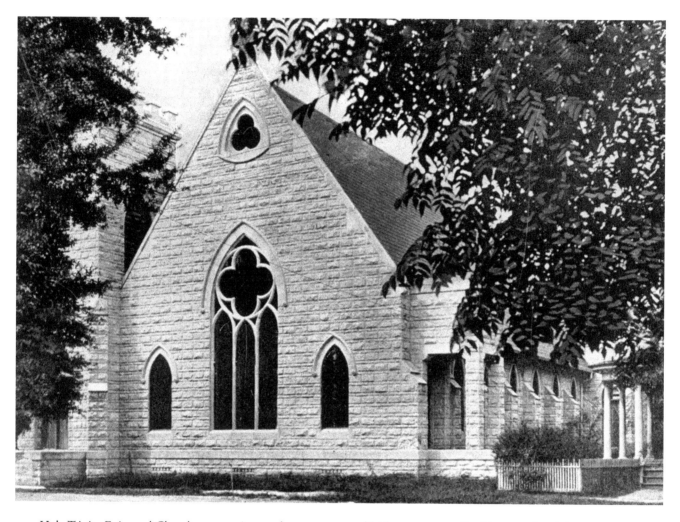

Holy Trinity Episcopal Church outgrew its wooden sanctuary and laid a cornerstone for this stone church in 1905 at 100-110 NE 1st Street. The first service took place in the then-uncompleted structure in 1907. On January 21, 1991, most of the building was destroyed by a fire, but the main stained-glass window shown here was saved because it had been removed before the fire for cleaning. The church was rebuilt with the original Gothic Revival design of Jacksonville architect J. W. Hawkins.

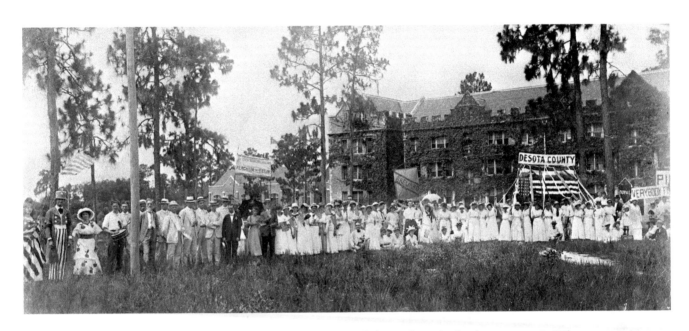

Gainesville residents early on were aware of the cost of education, and the need to raise funds to support it. When a campaign for a public school was begun in 1892, they came up with money for a quality school with heat and books. Shown here is a later rally to raise funds for education. The large building is Buckman Hall, constructed in 1906-7 and named for Henry Buckman of Jacksonville, who introduced legislation which resulted in the merger of several small schools into the University of Florida.

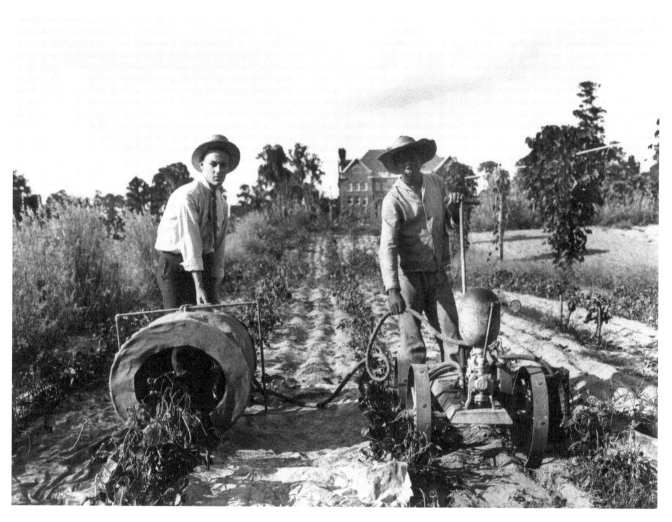

For 34 years, the building in the background of this photo was known as the Florida Agricultural Experiment Station. The grounds around it were landscaped to provide hands-on experience for students. These two men are shown performing a plant fumigation experiment around 1910. In 1944, the building was renamed Newell Hall to honor Dr. Wilmon E. Newell, director of the station from 1921 until 1943. It was placed on the National Register of Historic Places in 1979 and serves today as the university's center for soil and water science.

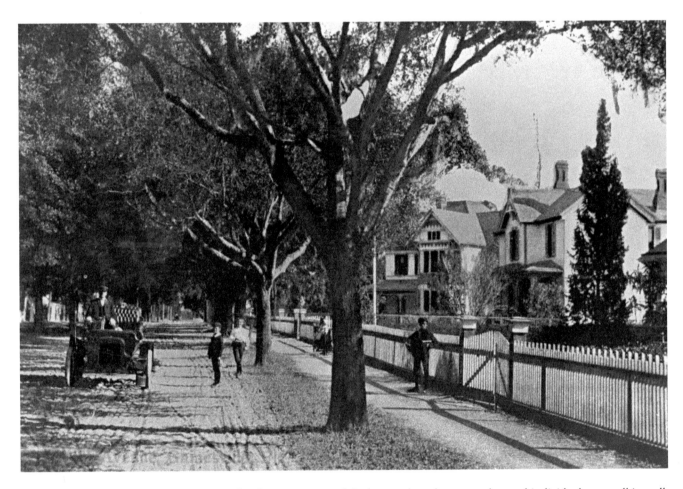

Around 1908 Alachua Avenue features a picket fence, a canopy of shade trees, large homes, and several individuals out walking, all consistent with a scene of early American tranquillity. It also features one of the hazards for early automobiles—streets constructed for horses, with ruts and soft sandy spots. During inclement weather, many of the streets became impassable.

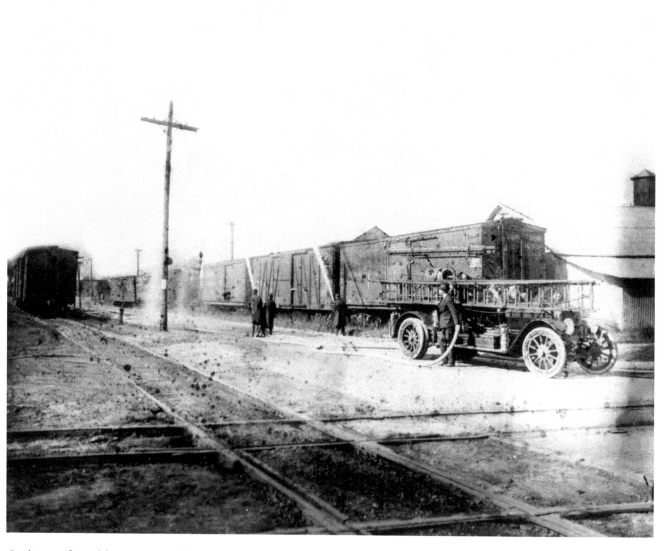

In the era of wood-burning or coal-burning steam locomotives, fires were a real risk. Photographed here in the Gainesville railroad yard around 1915, firemen are spraying water. One theory is that they were having a practice run with their new pumper engine. Another is that they were aiming at a railroad car to the left, which appears to be venting smoke.

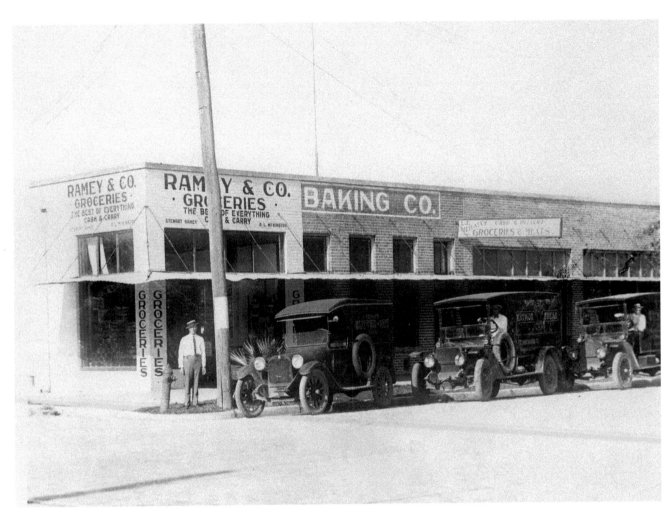

These delivery trucks are parked in front of their stores along West University Avenue at the southwest corner of the intersection with West 6th Street around 1915. Eatmor Bread delivered its butter-nut bread locally and shipped it to Tampa and Tallahassee from its 702-712 West University Avenue address. Ramey & Co. was a grocery store owned by Stewart Ramey and R. L. McKinstry. Also nearby were the L. F. Mehaffy Grocery Store and a fountain store and confectionery.

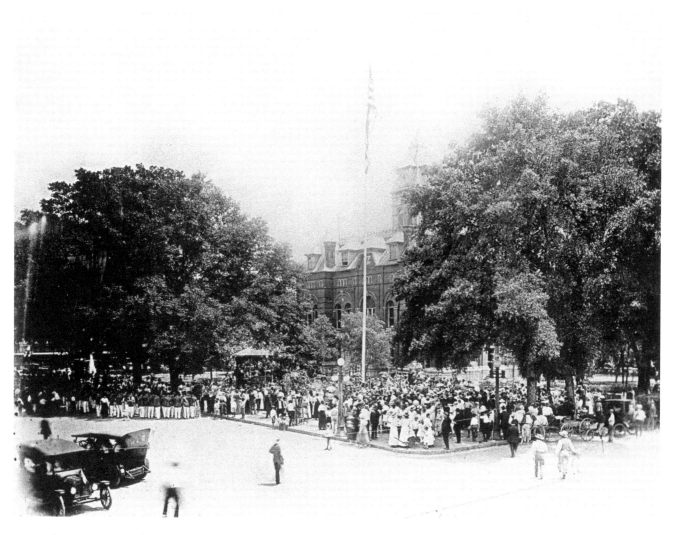

Shown here is a celebration at Courthouse Square, likely in the late 1910s. The group gathered beneath the large tree to the left is probably the marching band from the University of Florida. This may be a celebration of Independence Day. After a crushing Confederate defeat on July 4, 1863, with the fall of Vicksburg, the anniversary was not widely celebrated in the South for many years.

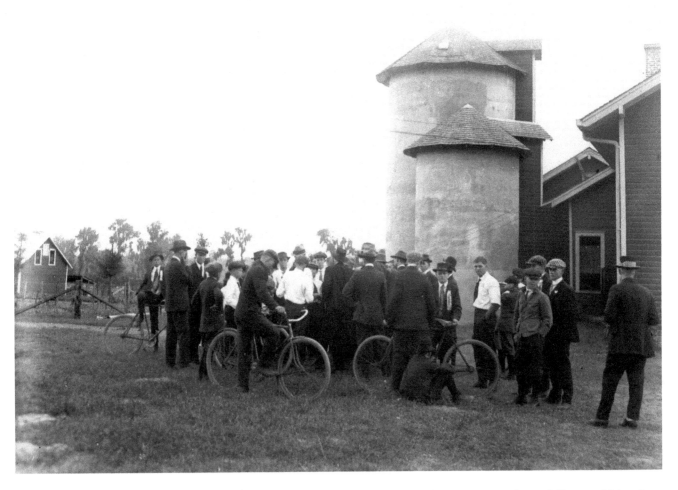

Florida 4-H clubs began with tomato clubs for girls and corn clubs for boys. Shown here in 1916 in front of silos on a University of Florida farm was the Alachua County Corn Club. Classes were conducted in the public schools and students then had the opportunity for hands-on experience in the field, under the supervision of experienced agents affiliated with the university.

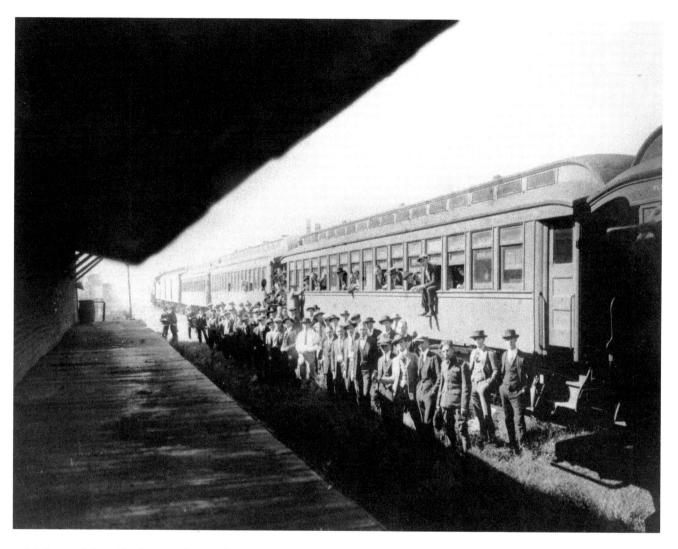

It is believed that this photograph was taken around 1917 at Gainesville's oldest remaining railroad depot, built of wood in 1907 at 203 East Depot Avenue on the site of the original depot. At the time, many young men were leaving by rail for basic training and eventual service in Europe during World War I.

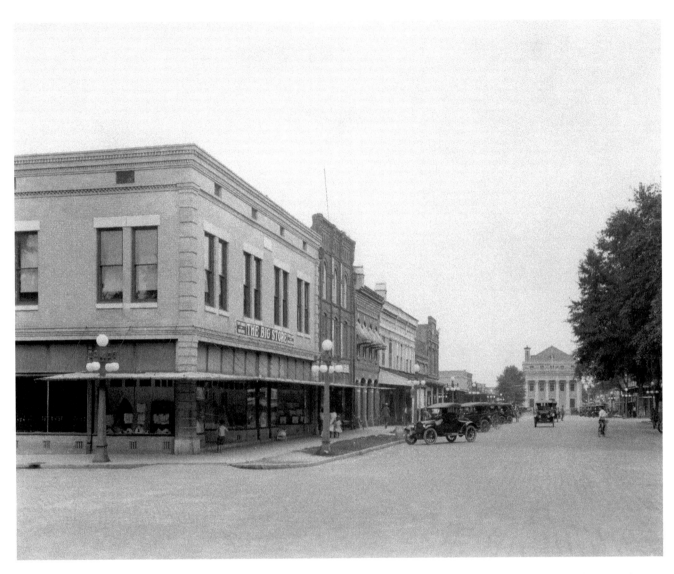

The east side of Courthouse Square as it appeared in 1919. The Big Store on the corner dominated the block, but five years later it was gone, with Baird Hardware adding it to the space where Baird began, the slightly taller building to the right. The fourth building on the block, at 141 SE 1st Street, later housed McCrory's dimestore. The two-story building on the next corner was the Phifer State Bank. The post office appears in the distance.

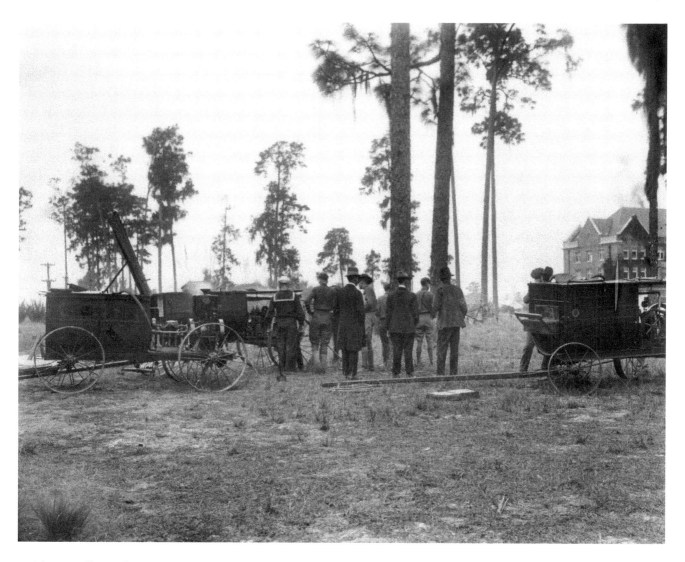

The Morrill Act of 1862 established Florida's land-grant university system, with proceeds from land sales invested in a perpetual endowment fund to support colleges of agriculture and mechanical arts. Florida Agricultural College, established in 1884, was a Morrill Act school, evolving in 1906 into the College of Agriculture at the University of Florida. The college's spraying machine, used to fumigate citrus trees, is being demonstrated here on January 16, 1919.

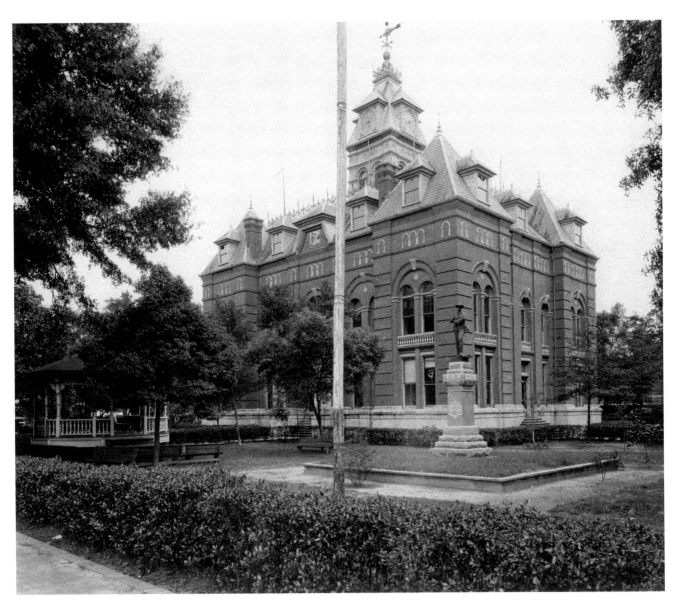

Shown here in 1919, the courthouse constructed in 1884 has undergone some changes. The roof has been redesigned, along with the clock tower. The trees on Courthouse Square are much larger, and beneath them stand a flagpole and a bronze Confederate soldier sculptured by John G. Segesman in 1904. It was cast by W. H. Mullins of Salem, Ohio, and was dedicated by the Kirby Smith Chapter of the United Daughters of the Confederacy.

GROWTH OF THE CITY AND THE UNIVERSITY

(1920–1939)

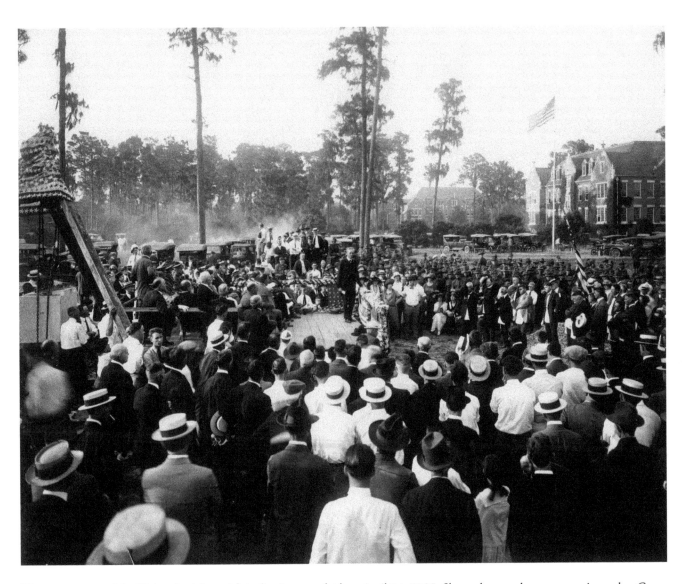

The cornerstone of the University Memorial Auditorium was laid on April 21, 1922. Shown here at the ceremony is speaker Cary Hardee, the governor of Florida. The building designed by William A. Edwards resembles a Gothic church and includes a chapel and large pipe organ. The north facade was incomplete in 1925, when construction was halted owing to lack of funds. The mostly finished building was used for university assemblies for decades until construction could resume.

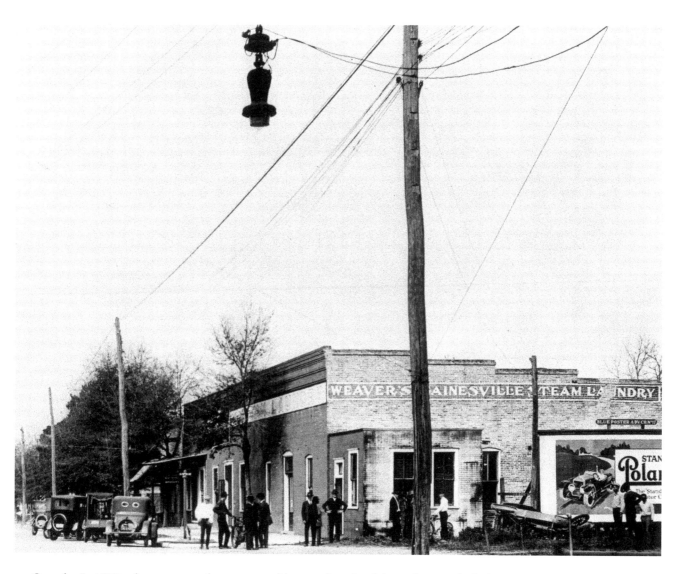

On a day in 1923, what appears to be an auto accident, perhaps involving only one vehicle, has occurred along West University Avenue. Behind the wreckage at 800 West University Avenue is Weaver's Gainesville Steam Laundry, and on its east wall is a billboard advertising Stanocola Polarine, the "Standard" Motor Oil. Stanocola stood for Standard Oil of Louisiana, one of the small oil companies created by the breakup of the huge Standard Oil Company in 1911.

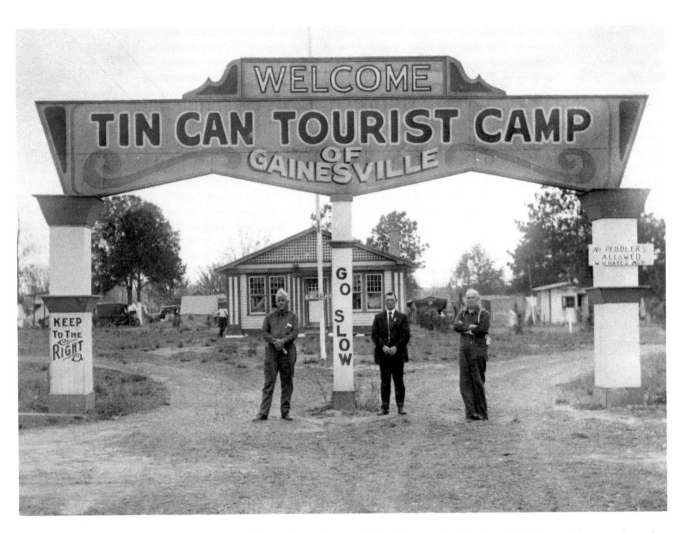

Carl Fisher's Dixie Highway brought thousands from the Midwest to Miami Beach, also developed by Fisher, with stops along the way both on a coastal route and an inland Florida route. In Alachua County, Tin Can Tourist camps were set up in Archer and along SW 2nd Avenue, the later site of Alachua General Hospital.

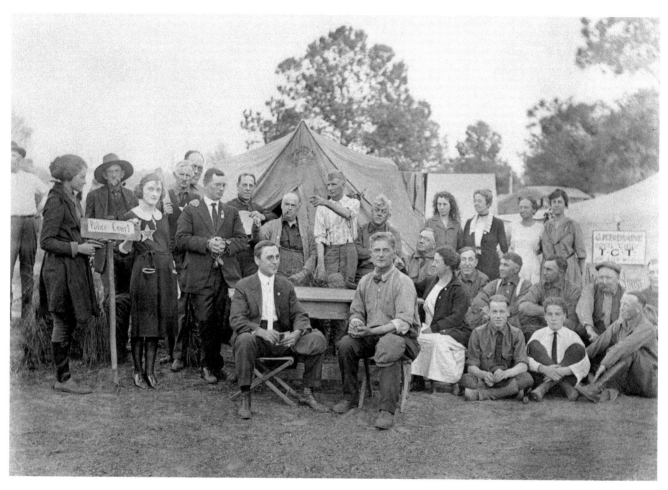

Tin Can Tourists enjoy camaraderie around 1921, as they brave the hardships of long-distance travel—living in the beds of trucks or automobiles with folding side tents and eating their meals from tin cans. Many were members of the national Tin Can Tourists club, formed in Tampa's DeSoto Park in 1919, and frequently turned their temporary visits into one-way trips. One club member could recognize another by the tin can soldered to his radiator cap.

The university's Institute of Food and Agricultural Sciences and its predecessor colleges and departments have been concerned from the start with improving methods of crop production in Florida. One crop is the pecan, shown here on October 28, 1924. Pecan trees can take ten to twelve years to begin producing nuts, but this specimen was apparently younger and was already producing.

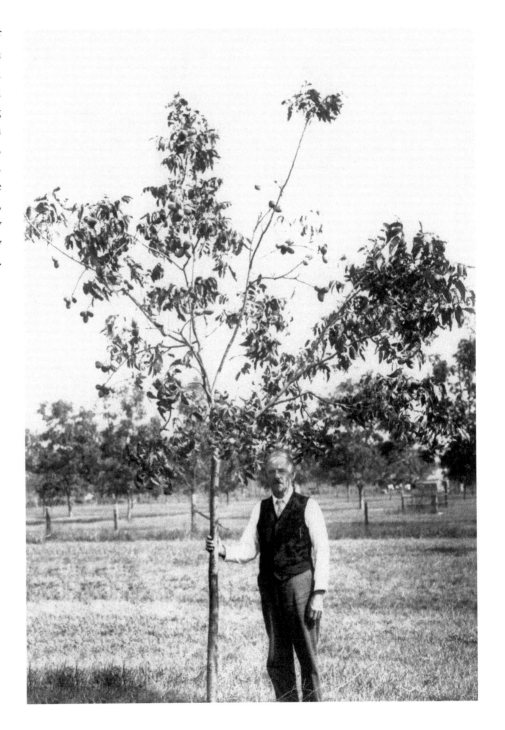

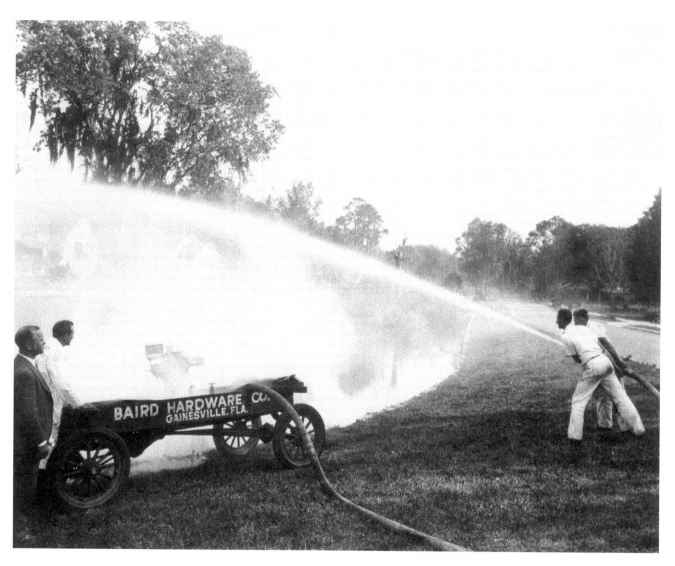

Shown here is a portion of Sunkist Villa, the land of William R. Thomas northeast of downtown. Surrounded by beautiful homes, it was a 100-foot-wide park with Sweetwater Branch flowing southward through it. Here in 1926, water is being pumped within that park during its transformation into the Duck Pond, one of Gainesville's first planned public green spaces. It is a popular place to relax and stroll, and waterfowl can often be found in the ponds there.

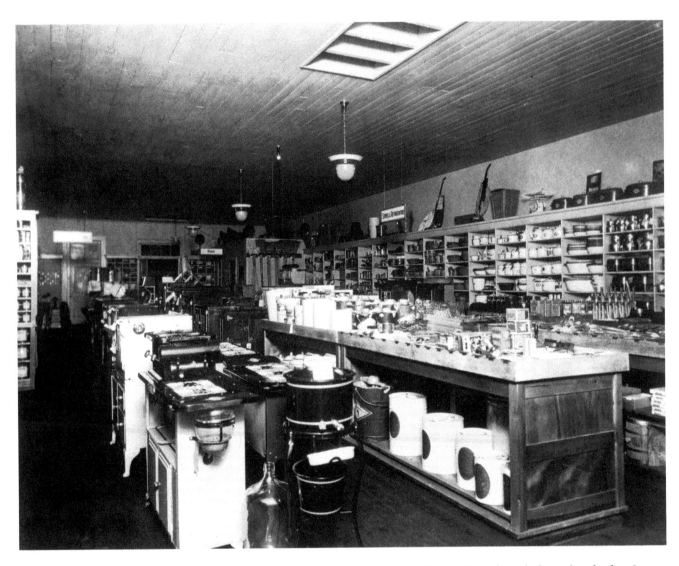

Baird Hardware was the only store in town with a large scale where customers could come in and weigh themselves for free. It was placed at the back of the store so that anyone walking across the creaking wood floor would be treated to the sight of household appliances, sports equipment, electric fans, scooters, and wagons such as those shown here. Many who came in for a free weighing walked out with unplanned purchases.

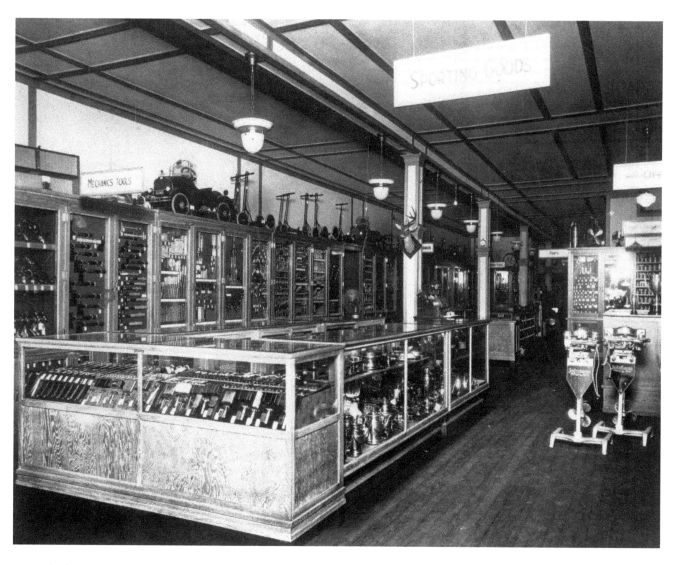

For Eberle Baird and the later owners of Baird Hardware, the store's inventory was to be more than tools and nails and lumber. A large part of what was sold was specifically for the hunter and fisherman. In addition to smaller items such as those shown here, Baird's sold boats and motors, which it demonstrated in Newnan's Lake. Beginning in the mid-1920s and continuing until 1936, the store was Florida's exclusive distributor for the Johnson Outboard Motor Company.

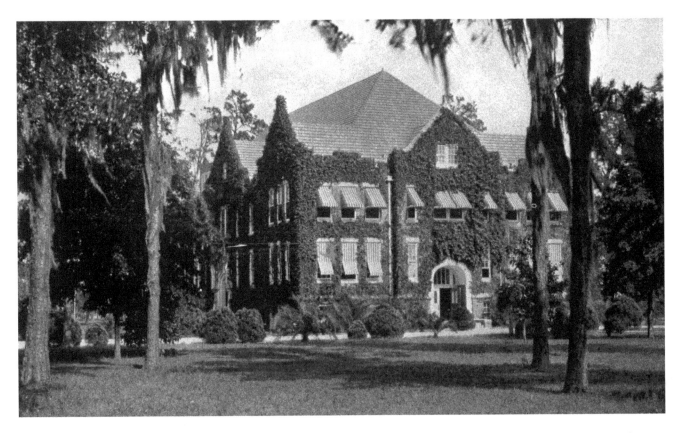

Originally known as Language Hall and housing humanities classes and offices, this ivy-covered brick building was designed by official Board of Control architect William A. Edwards and built in 1913. It was renamed Anderson Hall in 1949 to honor Dr. James Nesbitt Anderson, who taught Latin and Greek and served as the first dean of the Graduate School. Anderson Hall was placed on the National Register of Historic Places in 1979 and is now the headquarters of the departments of Religion and Political Science.

A large home was begun by Charles Chase in 1906, and William R. Thomas completed it in 1910 as his residence. It was expanded in 1926-28 and was operated as the luxury Thomas Hotel. Designed by William A. Edwards, it shows a French classical style and features festoons above doorways, arches, and a stuccoed exterior. The original residence served as a restaurant until 1968. After serving as a community college campus, it was acquired by the city in 1974 and converted to city offices and a cultural center.

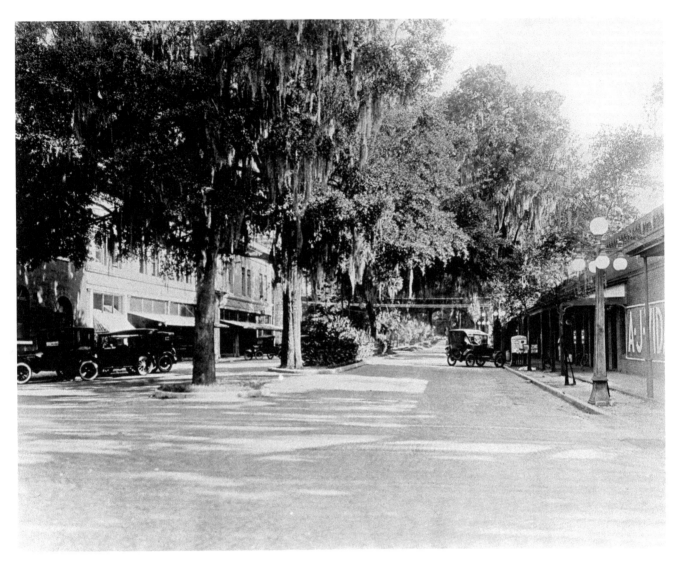

The photographer who made this image in the late 1920s was standing with Courthouse Square to his back, looking north along East Main Street. This is believed to be Gainesville's first street paved with brick, dating to 1905. The portion of the street close to University Avenue was a continuation of the commercial district around the Square, which gave way farther north to residences. When the streets of the city were renamed, East Main Street became East Main North, and is now NE 1st Street.

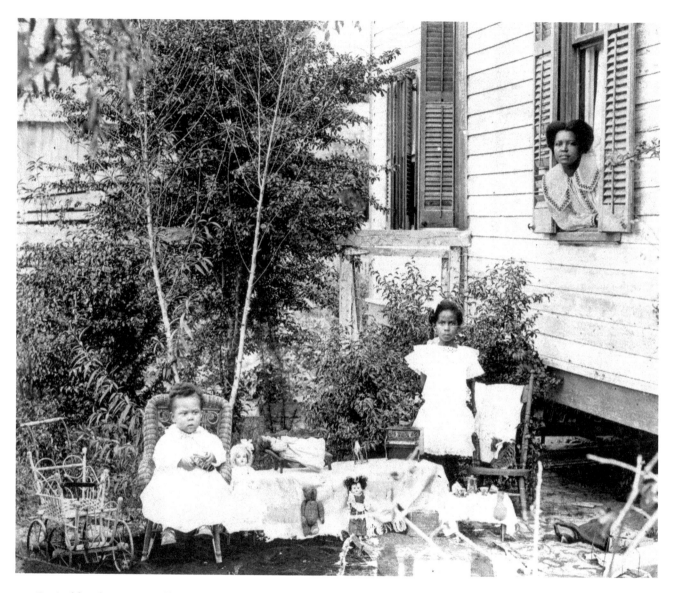

Reginald and Jannieve Williams are shown here having a tea party with dolls and other toys, likely in the yard of their home at 932 Arredonda Street (since 1950, known as 736 NW 3rd Street). Their mother, Emma Williams, keeps watch over them from the window. Emma and her husband, Hampton C. "Hamp" Williams, were teachers at the Union Academy.

W. McKee Kelley of St. Petersburg came to Gainesville in 1925 and the following year began construction of the city's first skyscraper. F. Lloyd Preacher and Rudolph Weaver designed the luxury Kelley Hotel with a Mediterranean revival style. Half of the projected $600,000 cost was to come from Kelley and half from local investors. The planned grand opening date of January 1, 1927, came and went. The superstructure had reached nine stories, but Kelley ran out of money and it stood unfinished for a decade.

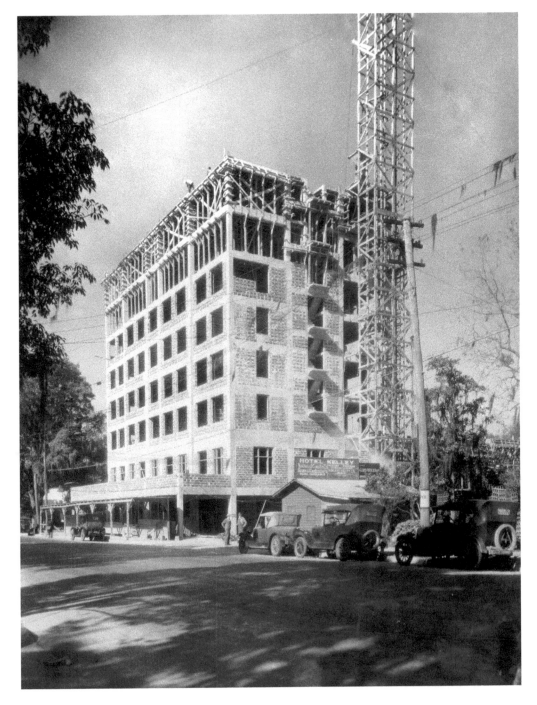

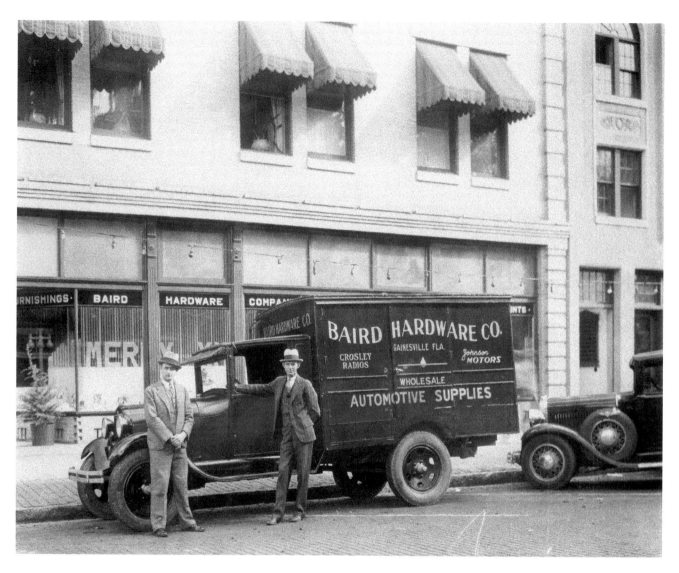

The Baird Hardware delivery truck is parked in front of its expanded store room, at the southeast corner of University Avenue and SE 1st Street, which it acquired in 1924. It was Christmas time, and Baird's was a popular place to buy gifts. In 1975, the block was razed to make room for a new courthouse. The company dissolved in 1981 and donated its warehouse property on South Main Street to the University of Florida.

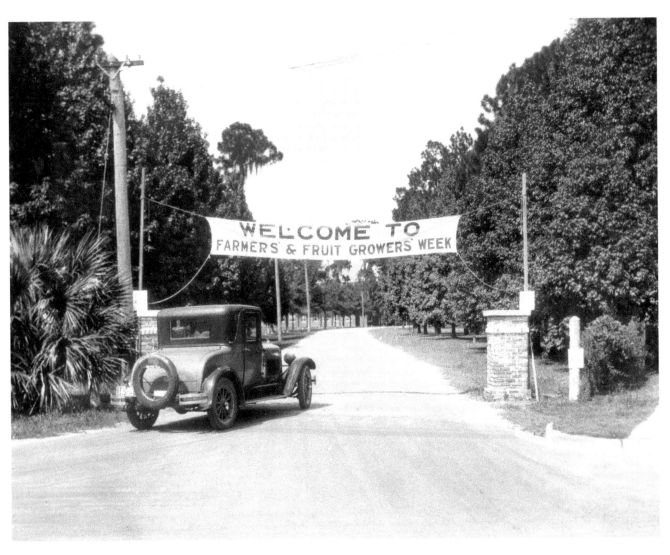

In 1914, the Smith-Lever Act made federal financial support available for educational programs. Shown here is the entrance to the university campus during one series of such programs, held during the Farmers' & Fruit Growers' Week put on by the university's College of Agriculture. Since 1964, the Institute of Food and Agricultural Sciences of the University of Florida has provided the citizens of Florida with lifelong learning programs in agriculture. Every county has an extension office available to all.

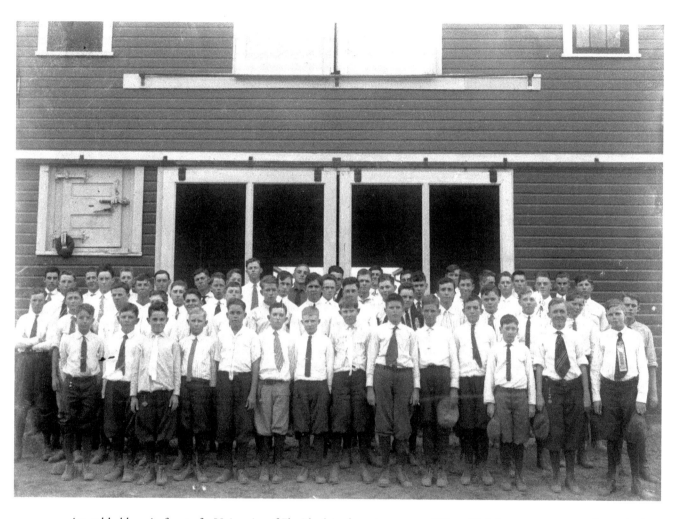

Assembled here in front of a University of Florida dairy barn is a group of Corn Club boys, on campus to learn the best techniques from trained agricultural agents. Parents often served as volunteer assistants in the educational programs, which were designed not only to teach those who attended, but also to encourage them to return home and share what they learned with their parents and peers.

Pictured here during the 1920s is the intersection of West University Avenue and 13th Street, with the campus of the University of Florida extending to the southwest corner on the right. To the left of that, on the southeast corner, was the Sigma Alpha Epsilon fraternity house, with the Pi Kappa Phi house just beyond. They were torn down during the 1960s and off-campus rented fraternity houses were replaced with new ones at the south (Sigma Alpha Epsilon) and north (Pi Kappa Phi) ends of the new on-campus Fraternity Row.

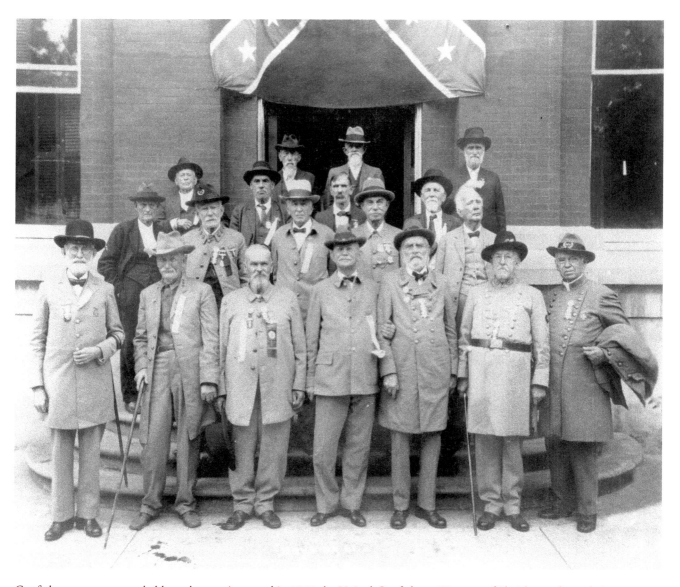

Confederate war veterans held regular reunions, and in 1888 the United Confederate Veterans of Florida was formed. At one time, Alachua County had about 135 men who had served in the Confederate army or navy, and 19 of them showed up on November 4, 1925, for a group photograph on the steps of the 1884 county courthouse. This image of the "Boys of '61" was captured by the camera of the Vansickel Studio, and includes General Lawrence Jackson in the middle of the front row.

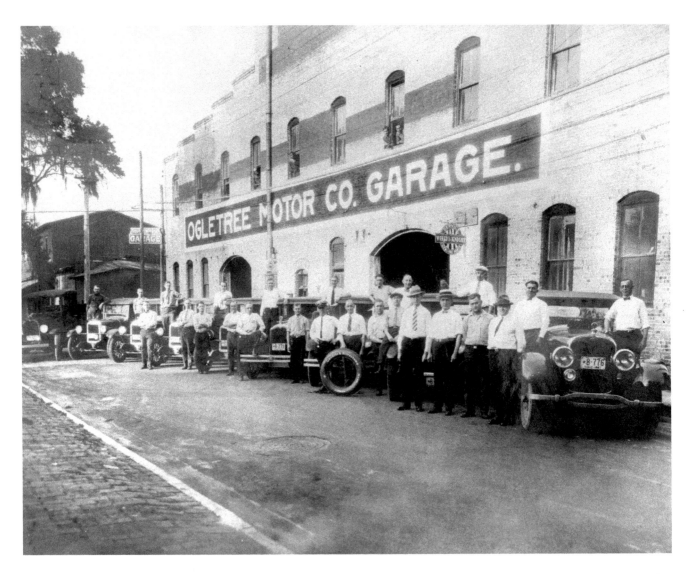

B. F. Goodrich was just one of the tire manufacturers which outfitted fleets of cars and sent them out in testing and promotional tours during the 1920s. This one stopped by the garage of the Ogletree Motor Company on March 23, 1927. The large garage of O. Brannen Ogletree was located at 129 NW 1st Street. This garage burned down in 1940. Mr. Ogletree, who went into business in 1919 and sold cars with makes such as Willys-Knight, Overland, and Hudson, remained in business until 1952.

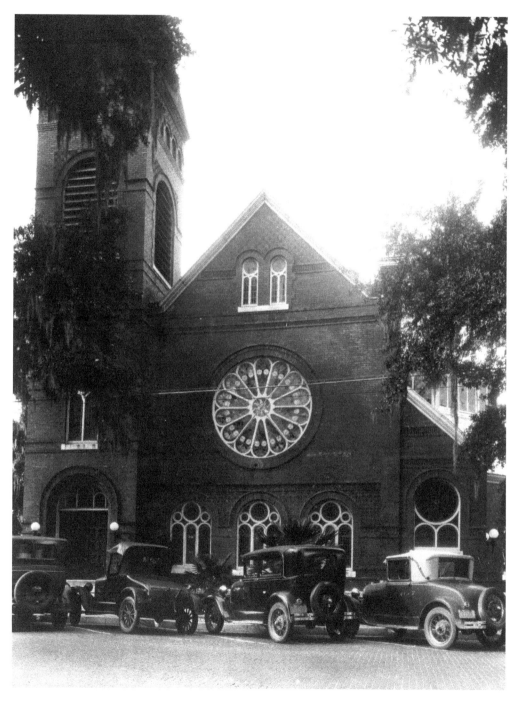

The first Presbyterian church in the area was the Kanapaha Presbyterian Church, which has stood miles southwest of downtown since 1859. In 1860, another sanctuary was erected on SE 1st Street, and the Presbyterians allowed the Methodists, Baptists, and Episcopalians to use it until they could build their own churches. The wooden 1st Street structure was replaced with this imposing brick building at the northwest corner of University Avenue and NW 2nd Street, which was used for services from 1890 until 1954.

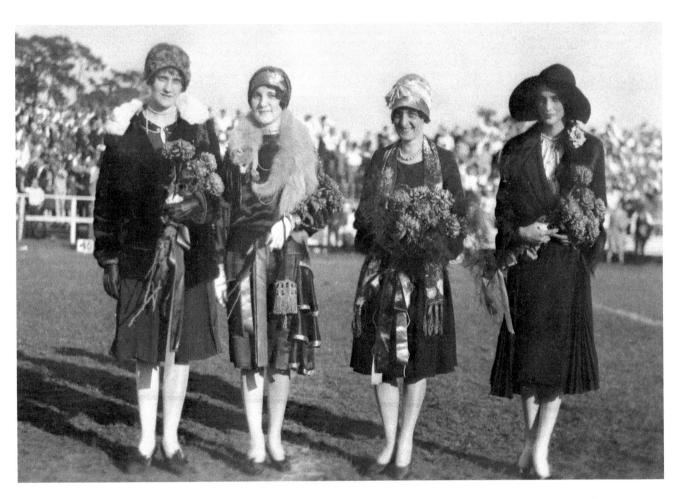

On November 6, 1926, these four young women were photographed on Florida Field at the football game between the University of Florida and Clemson University. It marked the third year of a tradition of alumni returning to campus to attend a football game and reminisce with classmates. On the field, the Florida Gators beat the Clemson Tigers by a score of 33 to 0. The only other game Florida won that year was the season opener against Southern, 16-0.

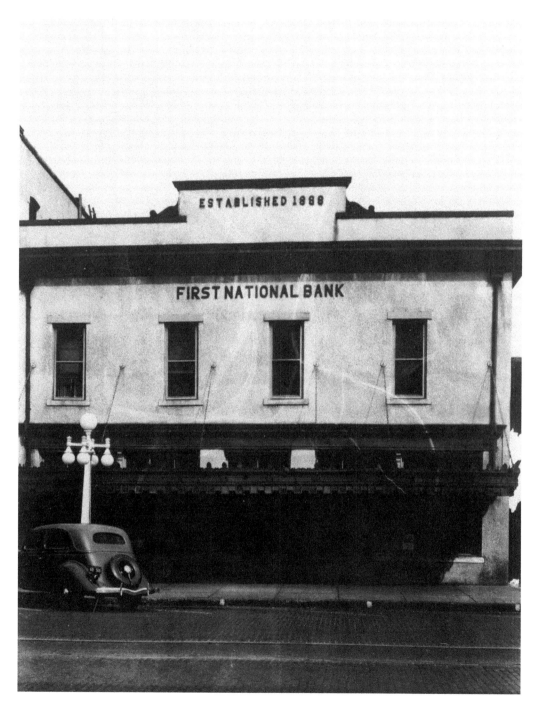

In 1888, the First National Bank of Gainesville was founded and moved into this building (later substantially remodeled) at 15 North Main Street. Across the street and a little to the north was its second home, completed in 1954 at 104 North Main Street, earlier the site of the ACL train station. That second bank building was razed after a new seven-story bank was completed next door. First National was Gainesville's only bank to survive the 1929 stock market crash and the ensuing Great Depression.

This cypress tree was photographed in 1930 along Prairie Creek, near the eastern edge of Paynes Prairie State Preserve. The preserve consists largely of the land formerly submerged beneath Alachua Lake, which was traversed by steamships and an elevated railroad trestle until the 1890s. During that decade, the natural drain at the bottom became unplugged, and most of the water drained out. What was left was the small Alachua Sink, which still holds water, and a large, dry plain used as pasture for cattle and bison.

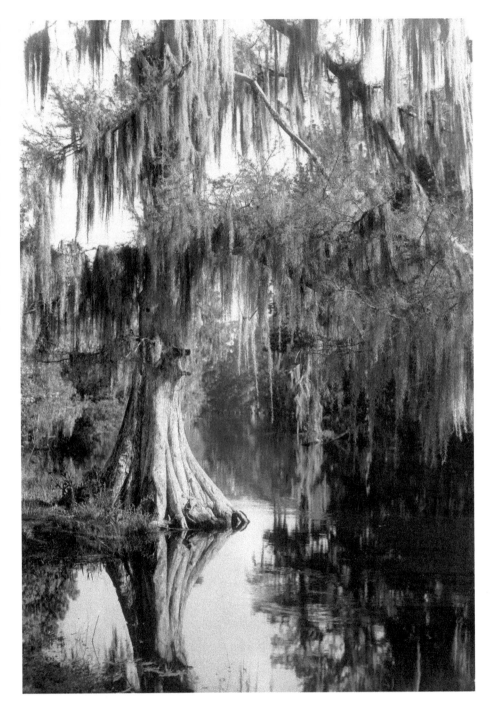

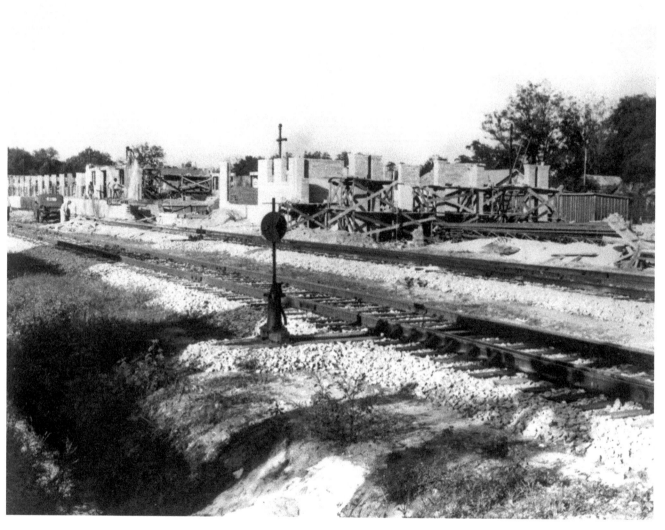

During the 1930s, the national economy permitted little new construction other than that supported by government programs to get the unemployed back to work. The Civilian Conservation Corps was very active in Florida parks, and the Federal Emergency Relief Administration and Works Progress Administration focused more on the cities and towns, often yielding buildings for public use. This new concrete work along Gainesville's railroad tracks may be some of that construction.

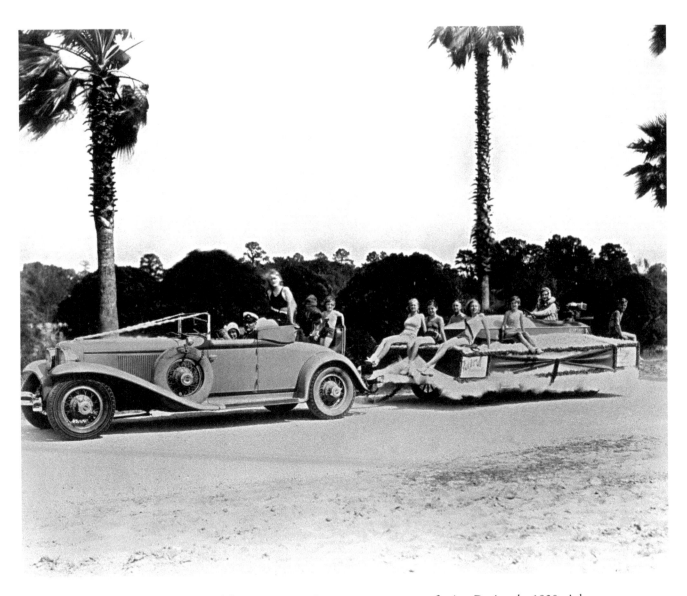

Tung oil is a solvent made from nuts and for a time was an important component of paint. During the 1930s, it became the largest crop grown in Alachua County, which produced 90 percent of all tung oil manufactured in the United States. It helped the area's economy during the Great Depression, and tung oil festivals featured floats such as the one shown here. The tung oil crop was hurt by freezes, and synthetic solvents were developed during World War II, greatly reducing the country's need for the substance.

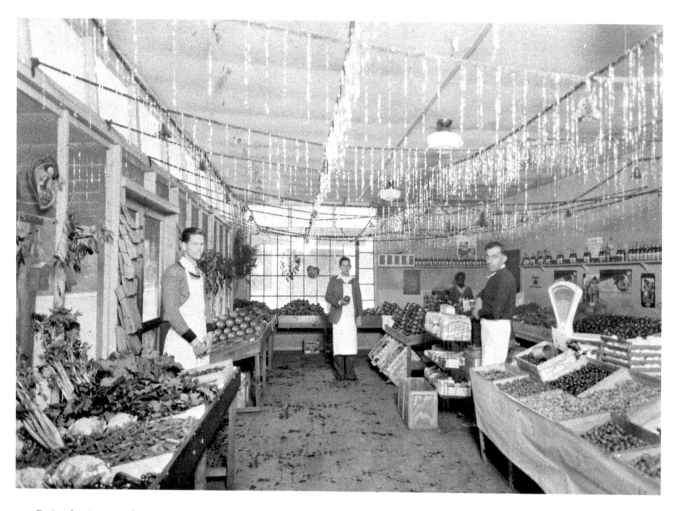

Doing business in the 1930s is one of Gainesville's fresh produce stores, the Happy Market. Unlike today's supermarkets where fruits and vegetables are pre-weighed and pre-packaged, markets like this one employed clerks like Russell Bullard, at left, to weigh and bag just what the customer desired. The store was managed by H. S. Nofal, the man wearing the dark shirt, at right.

This is the east side of Courthouse Square as it appeared in the late 1920s and early 1930s. The large two-story building housed retail businesses and later became the home of McCrory's 5 and 10 Cent Store. The two-story building on the right was the home of Phifer State Bank, founded in 1913 by Henry and William B. Phifer. It became Florida Bank at Gainesville in 1946, and later First National Bank. The buildings shown here were torn down in the early 1970s to make room for a new courthouse.

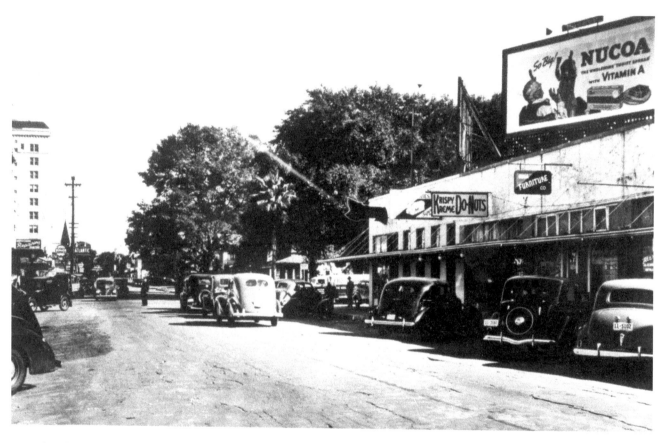

Today, the tall Seagle Building is all that remains from this 1937 view of University Avenue, facing east toward Main Street. Just to the right of the Seagle is the First Presbyterian Church tower and across the street are tall oak trees, both later eliminated for commercial development. In the block of stores to the right is one of the first Krispy Kreme Donut shops—the very first one opened in Winston-Salem, North Carolina, on July 13 the same year.

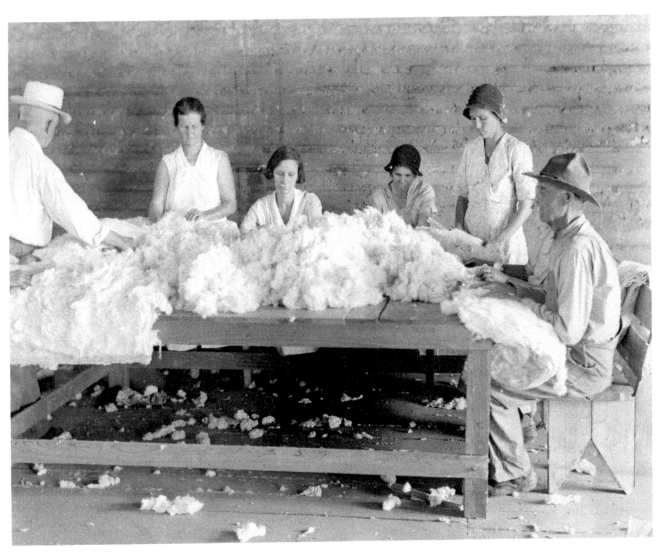

Spanish moss was easily collected from trees for use in local industry. After unwanted substances were removed by a company such as the Gainesville Moss Ginning Company at 320 NW 5th Street, the moss could be used for several purposes, including the stuffing of mattresses. Another stuffing material was cotton, being used here on April 4, 1935, in a mattress factory set up by the Federal Emergency Relief Administration to provide jobs for those hit hard by the Great Depression.

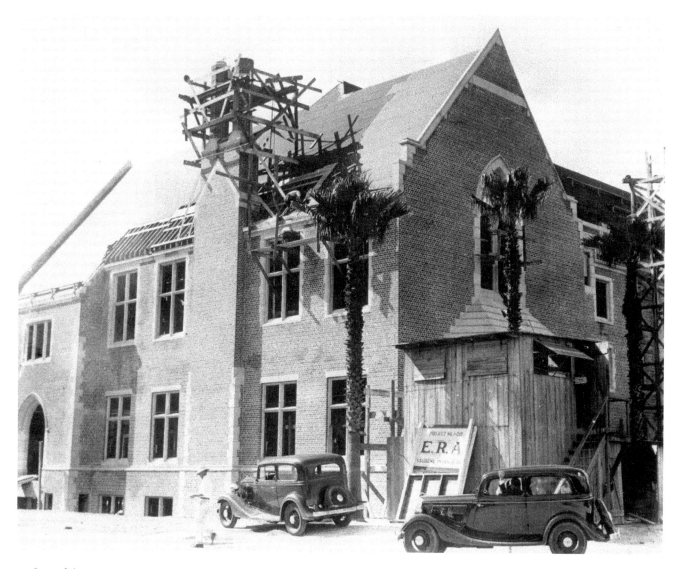

One of the area's projects under the auspices of the Federal Emergency Relief Administration was the Arts and Sciences Building for the university, shown here under construction in 1936. It included a new Student Union, and a second floor for use by the Religion Department and the YMCA. The building served as the Student Union for 30 years, then was converted to offices and classrooms and renamed for Manning Dauer, who had served as the chair of the Department of Political Science.

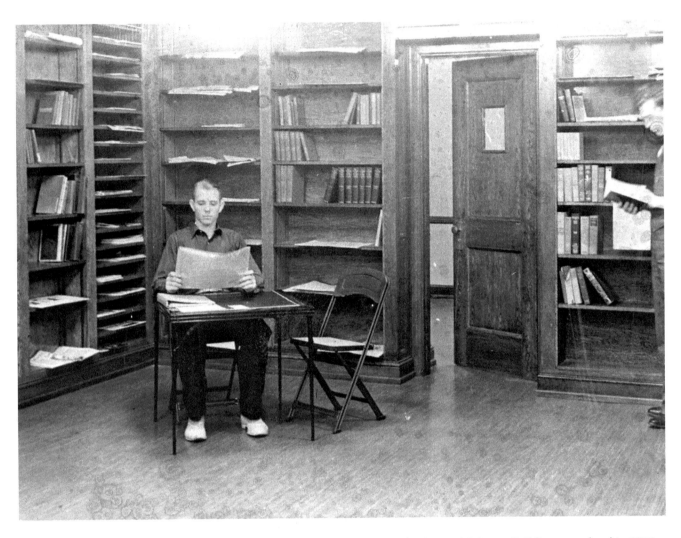

The first building on the university campus designed as a Student Union was the Arts and Sciences Building, completed in 1937 on Union Road, with help from William Jennings Bryan, who raised $79,682 for its construction because it was going to include a chapel. It also held a soda fountain, a bookstore, a sundry shop, hotel rooms for visitors, a game room, a student organizations office, and the reading room shown here. The chapel room remains with its stained-glass window, although it is no longer used for religious services.

MODERN GAINESVILLE

(1940–1960s)

The unfinished Kelley Hotel, also known as the Dixie Hotel, was saved by the Works Progress Administration, a $20,000 gift from University of Florida supporter Georgia Seagle, and the same amount by the city and county through taxation. The plans were revised by the university's School of Architecture, and ownership was transferred to the state. In the 1940s, it was named the John F. Seagle Building, for Georgia Seagle's brother, and it remains downtown's tallest building. It was converted into luxury condominiums and office space in the early 1980s.

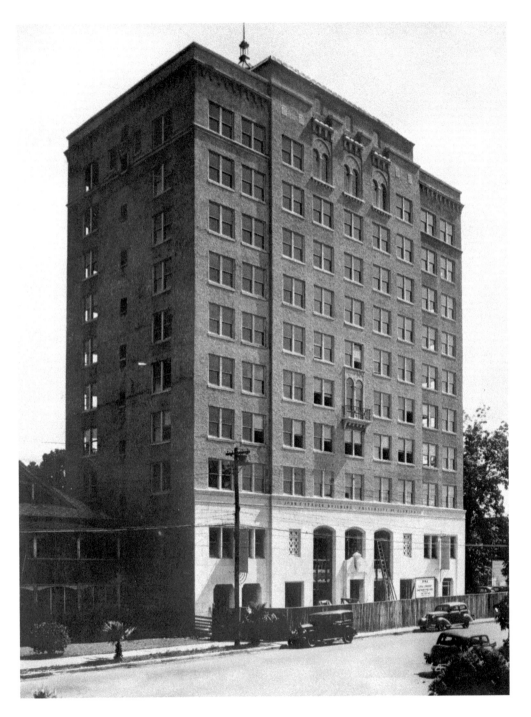

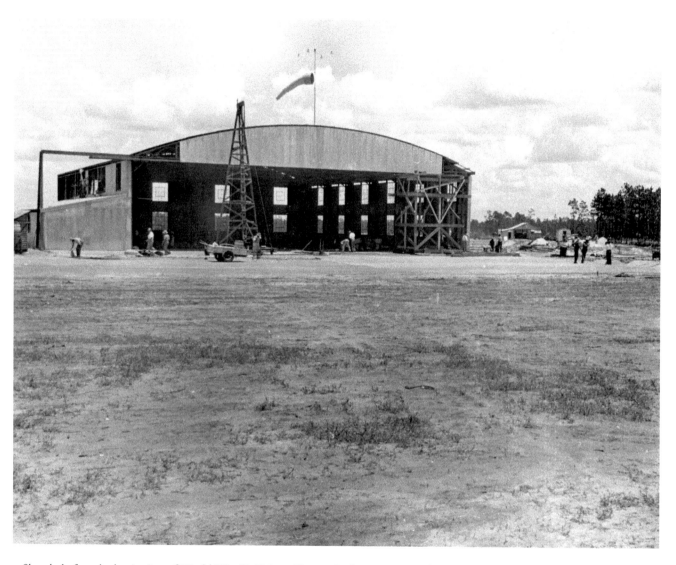

Shortly before the beginning of World War II, Gainesville acquired 150 acres northeast of downtown and constructed an airport, which was expanded by the WPA into the Alachua Army Airfield. It was used by the Army Air Corps and the Army Air Force, and in 1942 was named the John R. Alison Airport to honor a University of Florida alumnus who served with distinction as a trainer and observer during the war, and later became the Assistant Secretary of Commerce for Aeronautics.

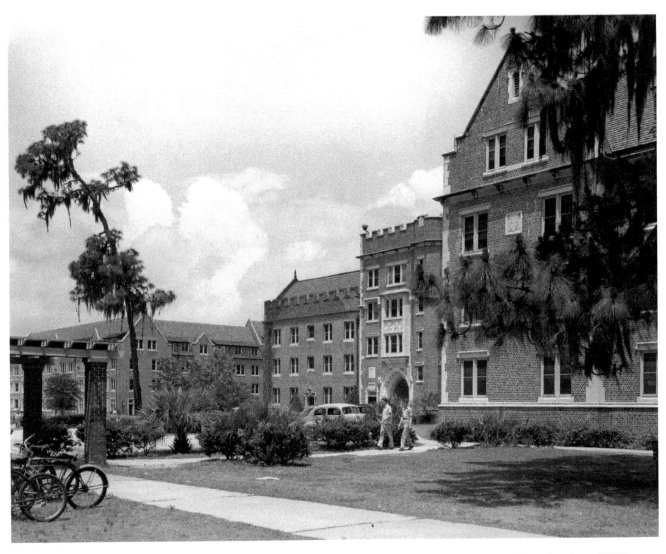

In 1905, the Board of Control asked architects to submit plans for the new university campus. Selected was the plan of William A. Edwards, whose firm of Edwards and Walter designed most of the early Collegiate Gothic–style buildings. During the 1920s, Edwards was succeeded by Rudolph Weaver. Shown here from left to right are four of their buildings, which are still standing—Muphree Hall (Weaver, 1939), Thomas Hall (Edwards, 1907), Sledd Hall (Weaver, 1929), and Buckman Hall (Edwards, 1907).

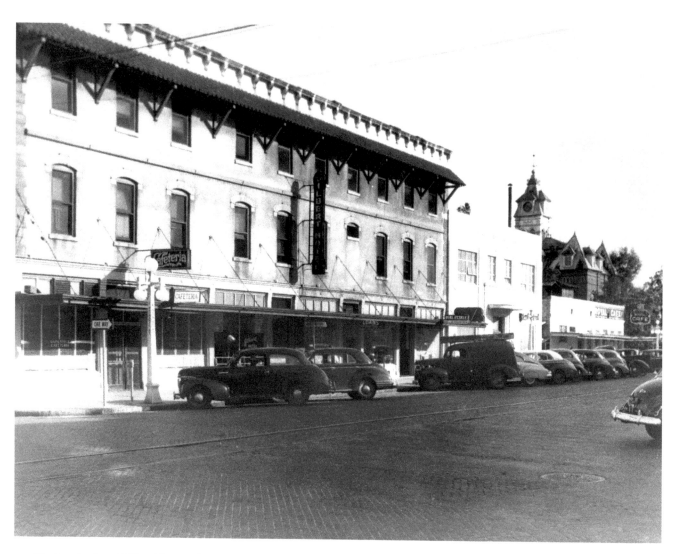

During the late 1940s, this was the appearance of the east side of Main Street, just north of University Avenue. The three-story building on the left was the Gilbert Hotel, earlier known as the Brown House Hotel. The establishment downstairs with the screen doors was the Gainesville Cafeteria, and next door was a real estate office. The two-story white building held the First National Bank. The last building on the block held the Royal Cafe, which faced south toward University Avenue and Courthouse Square.

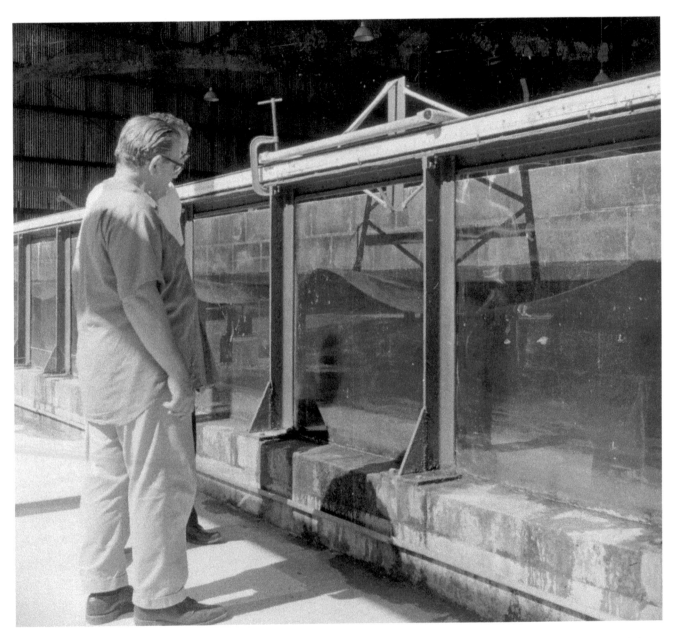

East of the main University of Florida campus is the Coastal and Oceanographic Engineering Laboratory, founded in 1957. The main facility in the cluster of buildings along SW 6th Street is the Coastal Engineering Wave Tank, shown here. The laboratory provides opportunities for oceanographers and engineers to study ocean waves and erosion.

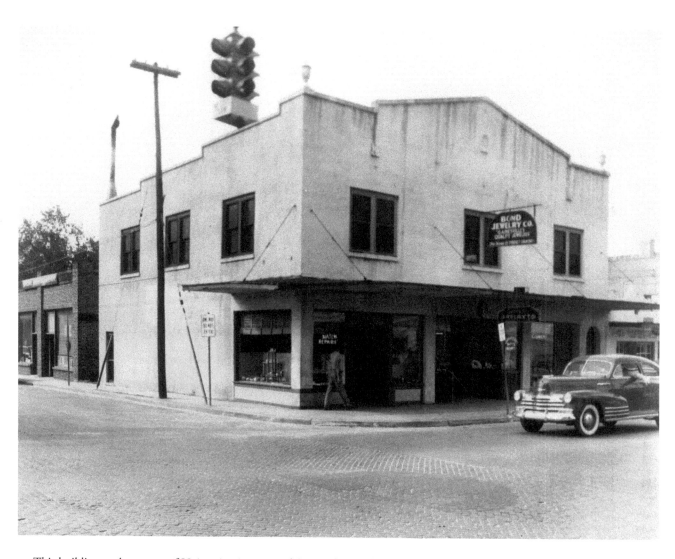

This building at the corner of University Avenue and SW 2nd Street has been the home of a variety of businesses over the years. Here in the 1940s, it was occupied by Bond Jewelry, owned by Frank H. Lewis, who also owned the competitor Lewis Jewelry right across the street. Lamar Hatcher later ran the Florida Gift Shop in this building. The first J. C. Penney Company in Gainesville opened here on September 21, 1956, and remained until 1978, when it moved to the Oaks Mall.

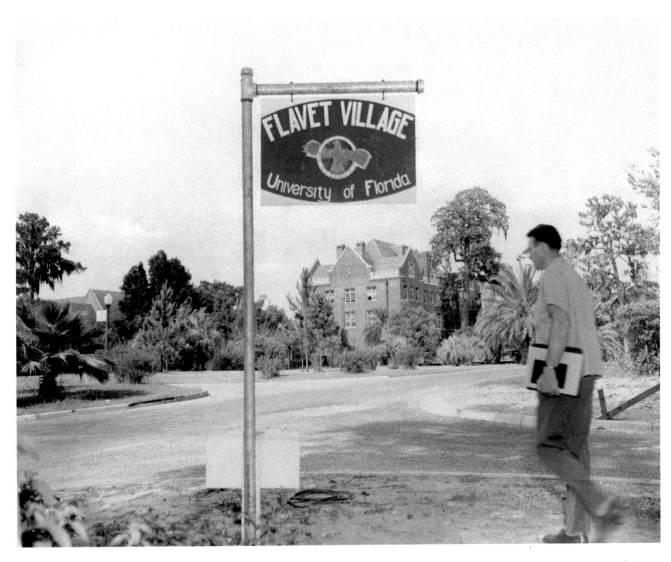

The end of World War II and the enactment of the GI Bill gave thousands of veterans the opportunity to begin or resume their college educations. Many of them, including J. Hozie Turner shown here in 1946, swelled the population of the University of Florida. For those who arrived with families, several Flavet villages (for "FLA VETerans") were constructed on campus with wooden barracks moved from military bases. Such structures housed married students until the last ones were razed in 1974.

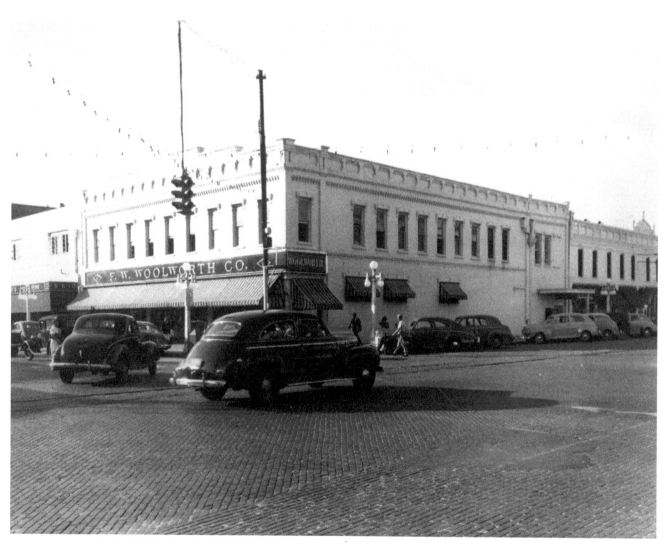

This large brick building at 2 West University Avenue was built by the Endel brothers as a dry-goods store to replace the Arlington Hotel, which had burned down. The dry-goods store moved out, and during 1907 on the first floor, the Gainesville National Bank moved in. Upstairs was the armory of the Gainesville Guards. The corner looked like this during the 1940s, with Woolworth's being a downtown fixture there from 1923 until 1982.

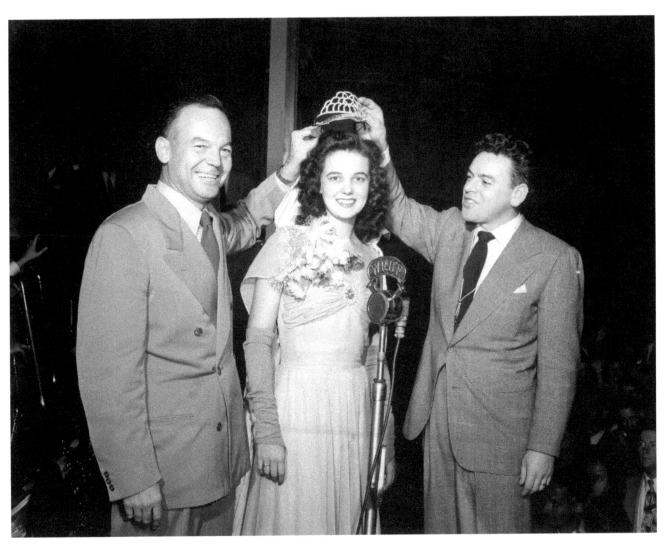

A beauty contest created by the editors of the 1947 *Seminole*, the university yearbook, began with finalists being chosen from photos submitted to future president Ronald Reagan and his first wife, Jane Wyman. Their choices appeared in the "beauty" section of the *Seminole*, and the finalists appeared in a contest judged by Zack "Smiling Jack" Mosley and bandleader Les Brown. Here at Brown's concert during the Fall Frolics, they present winner Nancy Barber of Orlando with a watch, luggage, and crown.

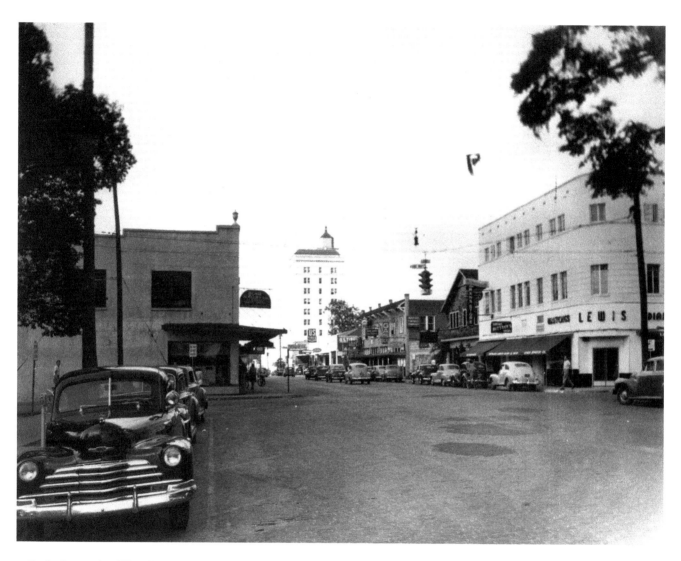

In the late 1940s, West University Avenue was a main commercial district. Shown here in the block from NW 2nd to 3rd streets was Lewis Jewelry; Bittner's women's clothing; Silverman's men's clothing; Primrose Grill with the slanted roof; Gainesville Gas; the Johnson Building with the offices of a dentist, insurance agent, and real estate agents; the Terry Gift & Book Shop; the Frank N. Anderson photography studio; Lillian's Music Store; a watch repair shop; and Shaw and Keeter Motor Company.

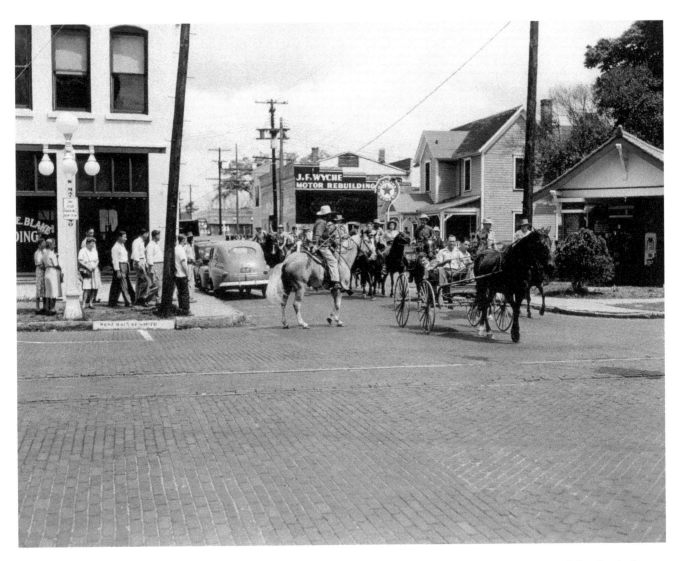

Shown here on the streets of downtown Gainesville are participants in a 1947 rodeo staged by the University of Florida Block & Bridle Club. That organization was formed by students as a social, educational, and service club, and worked closely with area 4-H clubs. It was affiliated with the National Block & Bridle Club, formed in 1919 by students from Kansas, Nebraska, Iowa, and Missouri to include all college students interested in animal science.

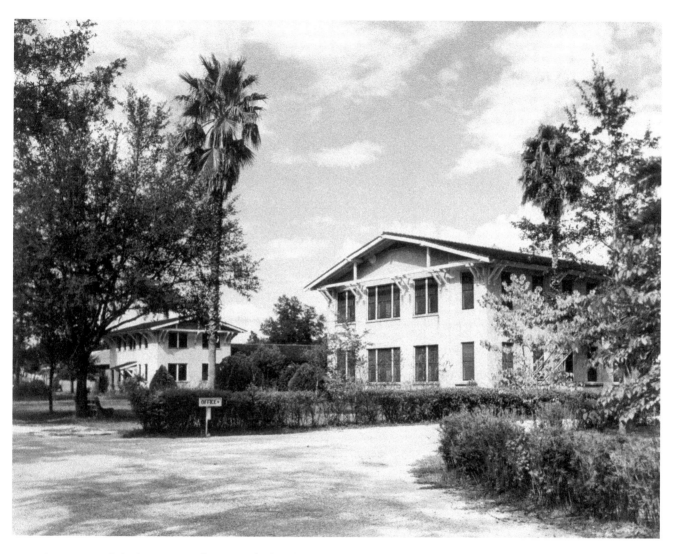

A state commission's recommendation resulted in the 1919 establishment of the Florida Farm Colony for the Feeble-Minded and Epileptic. This institution located east of downtown Gainesville isolated the developmentally challenged from the rest of the population. Some of its buildings are shown here in 1949, eight years before it was renamed the Sunland Training Center. Now called Tacachale, the 800-acre facility focuses more on training for employment and reintroduction into mainstream society.

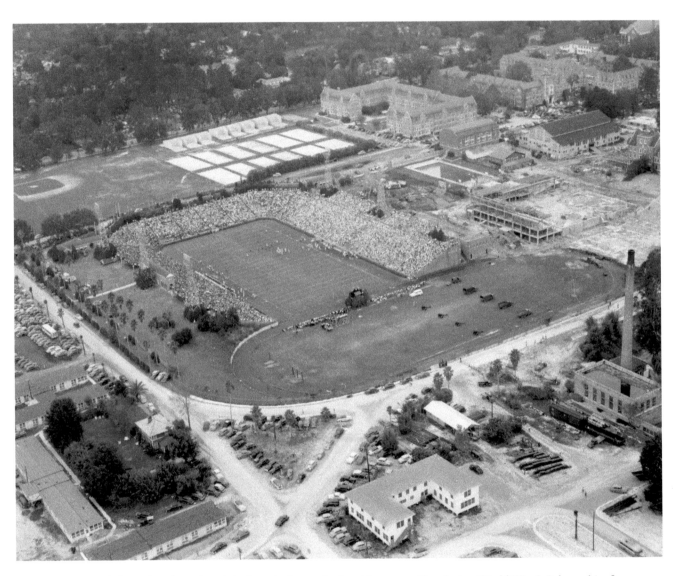

Florida Field was dedicated to the university's alumni who made the ultimate sacrifice during World War I. It hosted its first football game in 1922, when the seating capacity was 21,769. Benefactor Georgia Seagle donated money for the purchase of stadium lights and the construction of Georgia Seagle Hall as off-campus housing for athletes. The stadium was increased to a capacity of 72,000 in 1982 and 88,548 in 2003, 14 years after it was dedicated in the name of supporter Ben Hill Griffin, Jr.

A few fraternities were established about the time the university moved to Gainesville in 1906, and some had previously existed at its parent institutions. Others, such as Pi Lambda Phi shown here, were founded during the 1920s. When the Gainesville chapter was founded in 1925, it was known as Phi Beta Delta. The national Pi Lamb organization started at Yale University in 1895 and claims to be the first nonsectarian fraternity in the United States.

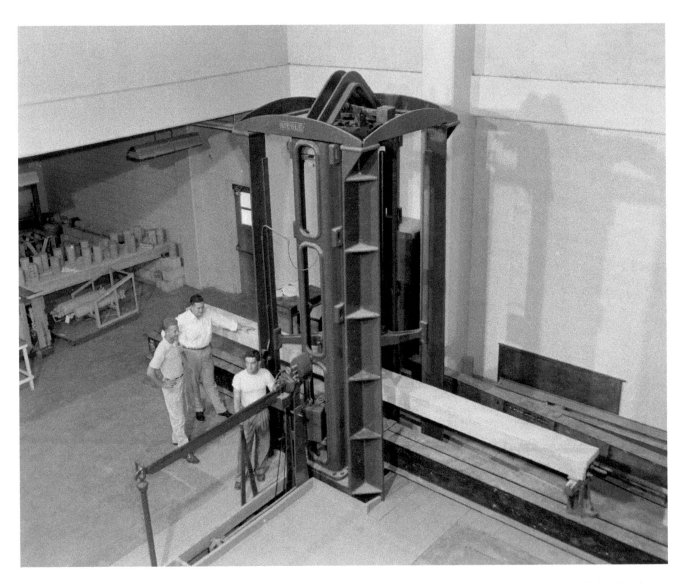

An important aspect of engineering is testing the strength of materials, often by compressing or twisting them until they break. Shown here in 1954 on the campus of the University of Florida is a Riehle vertical testing machine, which tested tension and compression at a pressure of up to 400,000 pounds. By adjusting a weight along a lever, the force exerted on a desired material was increased until it reached its breaking point.

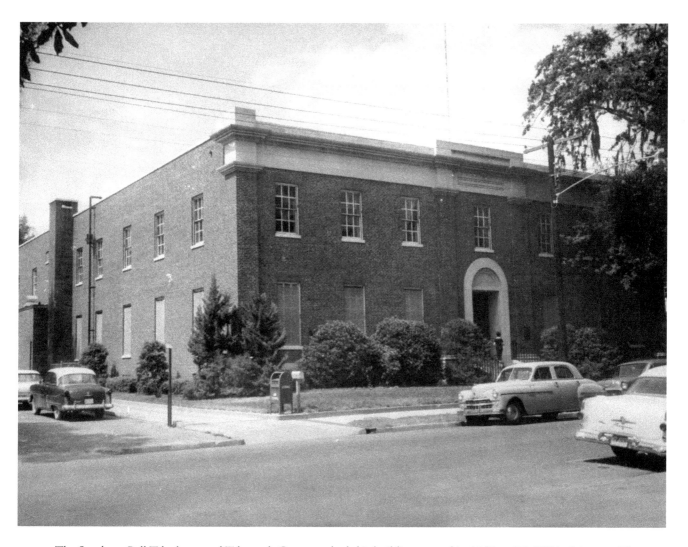

The Southern Bell Telephone and Telegraph Company had this building erected in 1948 at 400 SW 2nd Avenue. The two-story brick structure housed the phone company's dialing equipment, long-distance operating rooms, and administrative offices. After the building was razed, the property was added to another parcel to the north to provide a site for the federal building erected in 1965.

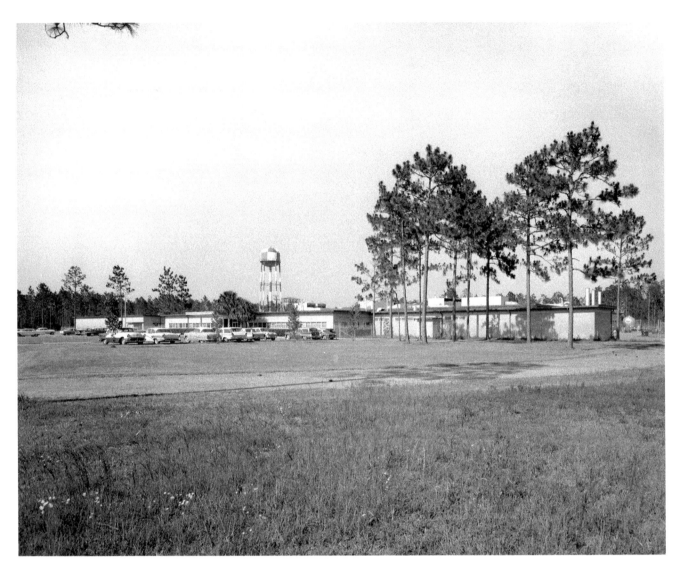

Founded as the Sperry Gyroscope Company in 1910, the company which in 1955 acquired Remington Rand and was renamed Sperry Rand Company was an innovator in the development of computers. It produced the UNIVAC series and in 1955 opened its $600,000 klystron electronic tube factory shown here. The property, located at 5301 NE 40th Terrace in the Airport Industrial Park, has been the home of the Gainesville Jobs Corps Center since Sperry Rand moved out in 1978.

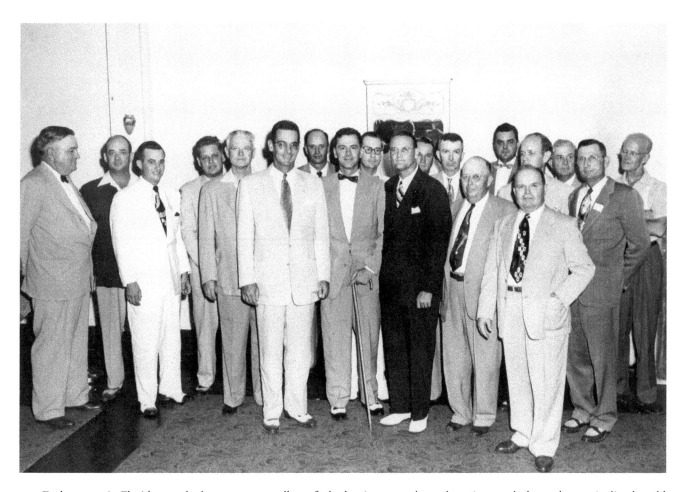

Each county in Florida once had one vote, regardless of whether it was rural or urban. As a result, lawmakers so inclined could block change on key issues until population-based representation was court-ordered in the 1960s. Florida lawmakers are shown here in 1953, including state senator J. Emory "Red" Cross and D. R. "Billy" Matthews (9th and 10th from left), both from Gainesville and University of Florida alumni.

In 1942, the federal government offered Gainesville funding for a recreation center, if the city would provide suitable land and operate it. Known as the Soldier Service Center, it opened in 1943 and was utilized by men stationed at the Alachua Army Airbase. The air base was returned to the city in 1946, and this facility was converted to civilian use. It is shown here during the 1950s when, as the City Recreation Center, it was a venue for dances and other activities.

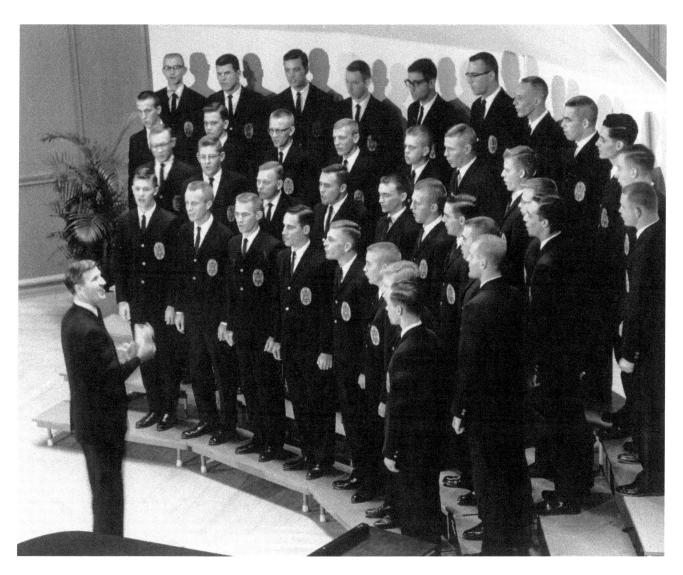

The first Men's Glee Club at the University of Florida was organized in 1907 by Klein Graham and existed for about ten years. The next one was formed in 1925 and continues today, joined by the Women's Glee Club (now called the Women's Chorale) in 1947 when the university went coed. Shown here is the club led by Guy B. Webb, who took over as its sixth director in 1959 and served in that capacity until 1966.

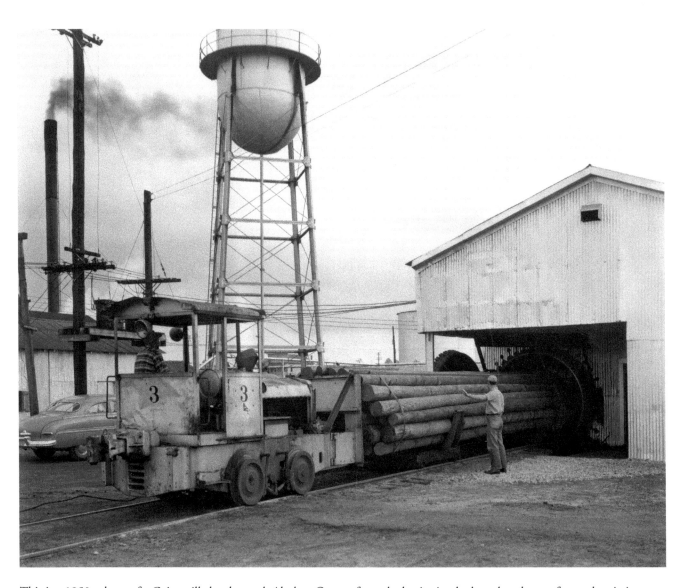

This is a 1950s photo of a Gainesville lumberyard. Alachua County from the beginning had an abundance of several varieties of trees, especially cypress, oak, and pine, which could be cut for building materials. During the early 1880s, the town's most prominent mill owner was B. C. Drask, and Leonard G. Dennis and Leonard Wallis partnered in lumber sales.

When Frank Pickel, a professor at the Florida Agricultural College in Lake City, purchased collections of fossils, minerals, and human anatomy models in 1891, he had no idea that it would form the nucleus of today's large Florida Museum of Natural History. In 1906, the collections were brought to Gainesville and stored on campus in Thomas Hall, then in Flint Hall. In 1937, many of the artifacts were placed on display in the Seagle Building, shown here in the 1950s. The museum was moved to campus in 1970.

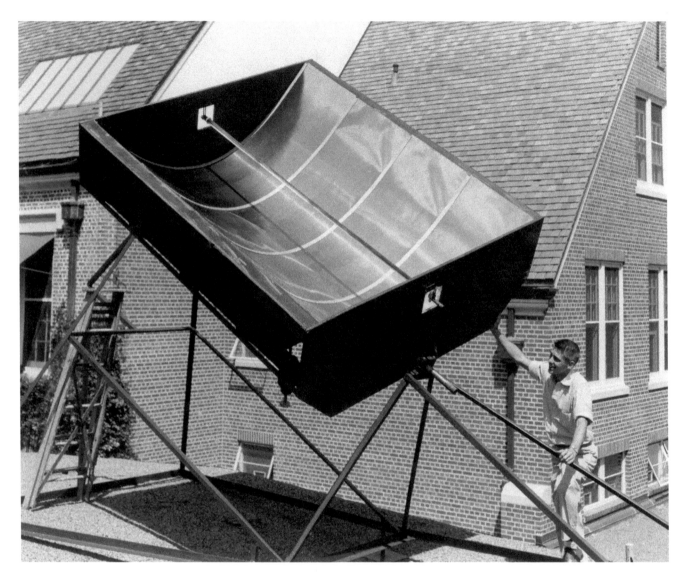

Shown here is a solar heat absorber, a project of Solar Energy and Energy Conversion Laboratory. Established in 1954 by Erich Farber, the engineering facility was honored in 2003 by the American Society of Mechanical Engineers for its years of wide-ranging research in solar energy leading to practical applications around the world. The university laboratory in the Energy Research and Education Park on SW 23rd Terrace was the 224th site to be designated a Historic Mechanical Engineering Landmark.

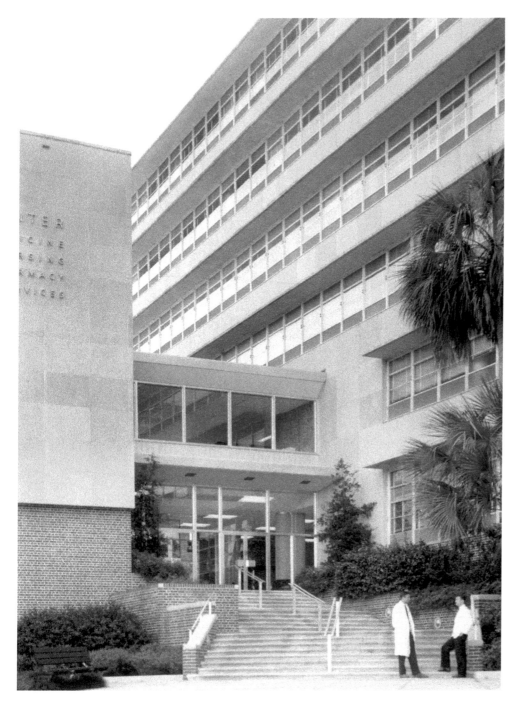

The site for the university's health center was selected on Archer Road because it was accessible by foot from campus, by vehicle from off-campus, and had lots of room for expansion. Medical students began classes in the first buildings in 1956, and three years later the complex shown here was dedicated as the J. Hillis Miller Health Center to honor the university president who had died in 1953. It includes the W. A. Shands Teaching Hospital, the Veterans Administration Hospital, and a veterinary teaching hospital.

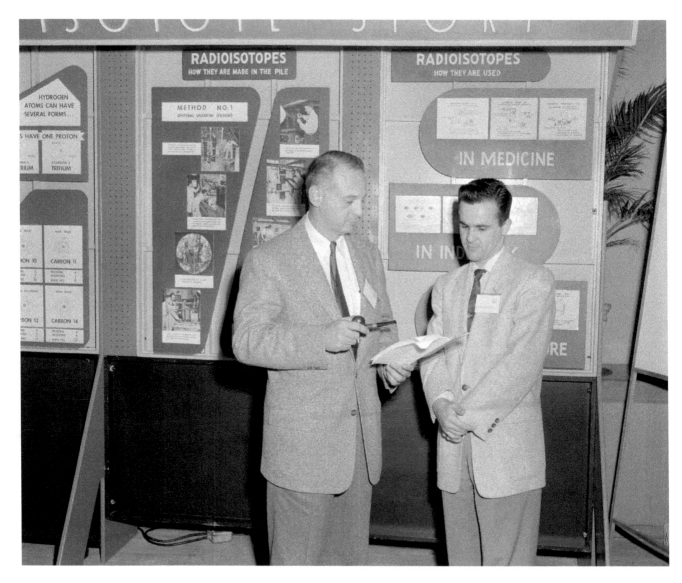

In March 1957, the University of Florida campus hosted the Newsmen's Seminar on Nuclear Energy. Shown here are participants conversing in front of display boards dealing with radioisotopes. A highlight of the seminar was a speech by James Keen, who in 1955 became the first chair of the state's Nuclear Development Commission. He advocated the establishment of nuclear energy programs at Florida State University with a particle accelerator, and at the University of Florida with a nuclear reactor.

This 1959 photo of the University Memorial Auditorium shows an impressive Collegiate Gothic structure, but it was still incomplete because of a lack of funds, which had run out in 1925. The original budget was for a construction cost of $100,000, but by the time the northern facade was completed in 1977, the total cost had escalated to about $6,000,000. The auditorium seats 867 and is the venue for special lectures and concerts.

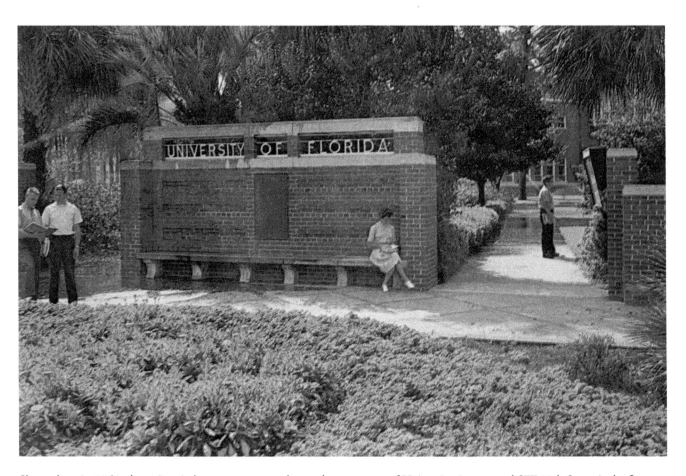

Shown here in 1960, the university's entrance gate at the southwest corner of University Avenue and SW 13th Street is the first part of campus to come into view when approaching from downtown. Behind the brick wall at the end of the sidewalk is Bryan Hall, which opened in 1914. Bryan succeeded Thomas Hall as the home of the law school, and during that same year a high school diploma was made a prerequisite to admission. Prior to that, one could enter law school upon completing the tenth grade.

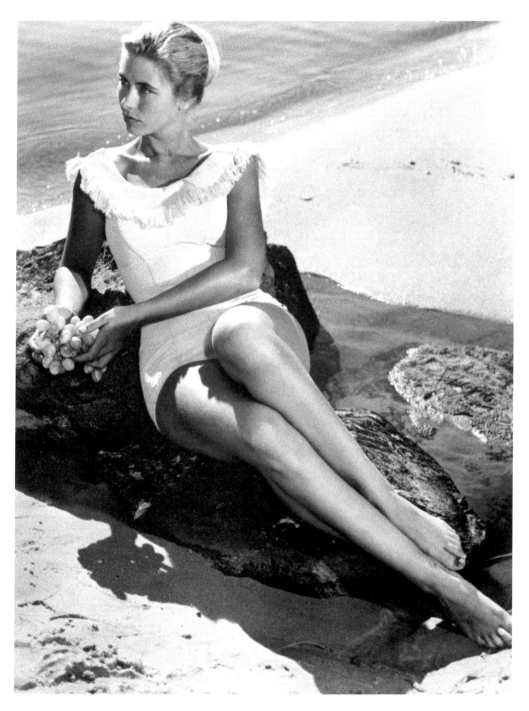

Nancy Wakefield is shown here in 1960 modeling beachwear of that time in a photo taken in Gainesville. She reigned as Miss Orange Bowl 1960, and she and her court presided over the annual Orange Bowl Parade in Miami on December 31, a prelude to that evening's football bowl game. The parade was first staged in 1936. Except for three years during World War II, it was an annual event until early 2002, when it was canceled because of a lack of television coverage and a decline in spectators.

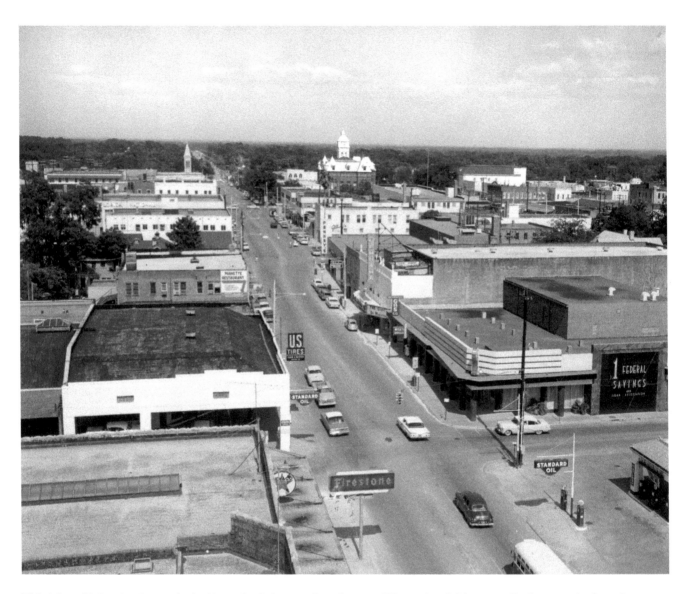

This is how University Avenue looked in 1960, facing east from between West 3rd and 4th streets. Easily recognized are the Firestone Garage and Shaw and Keeter Ford Building, the two closest to the foreground on the left. On the other side of the street at center is the angled marquee of the Florida Theatre, which opened in 1928 and remained the most popular theater in the city for decades. In the distance can be seen the towers of the 1884 Courthouse and the First Baptist Church.

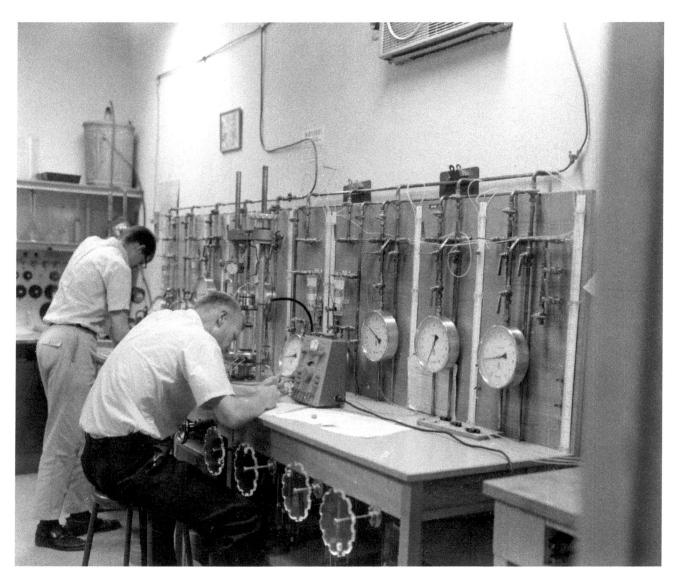

Begun in 1941 as the Engineering Experiment Station, the University of Florida Engineering and Industrial Experiment Station exists to conduct research that benefits Florida's industries, health, welfare, and public services. Areas of research conducted there include particle science, robotics, nanoscience, transportation, communications, and biomedical engineering. Student Peter Marshall and professor John Schmertmann are shown at work at the station in 1960.

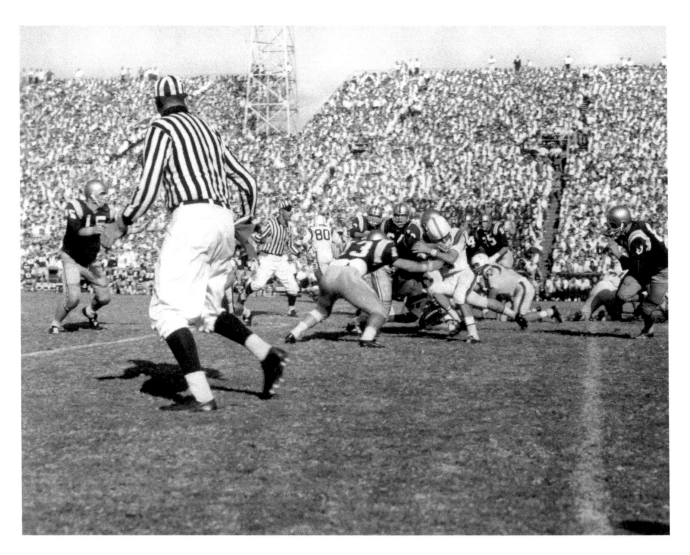

The Governor's Cup trophy is presented by the Tallahassee Quarterback Club to the winner of the annual game between the University of Florida and Florida State University. Neither won this game held on September 30, 1961—the game ended in a tie. The season turned out to be disappointing for the Gators, who finished with a record of 4-5-1. The Seminoles, who also finished with a 4-5-1 record, were less disappointed because, finally, they had not lost to the Gators. Each team was permitted to hold the trophy for six months.

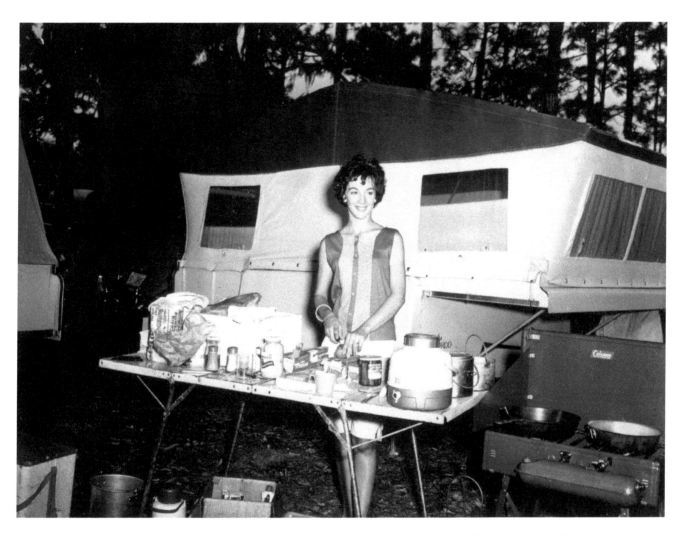

This young woman prepares a meal at a camping convention held in Gainesville in 1962. The University of Florida has long had strong ties with camping, especially as it relates to the 4-H program. The university has camping and conference centers known as Camp Cherry Lake, Camp Cloverleaf, Camp Timpoochee, and Camp Ocala. Goals of the program include increasing the understanding of self and others and the application of knowledge, skills, and attitudes to real-life situations.

The University of Florida considers its existence as a state-supported institution to have begun in 1853. One hundred years later it commenced work on the Century Tower shown here. Requiring two years to complete, since 1955 the tower has treated the campus to beautiful carillon music. The original plans called for the tower to be used as a museum and art gallery but these plans were scrapped. The carillon music was first produced by the Milton and Ethel Davis Carillonic Bells, which were replaced in 1979 by the 49-bell Century Tower Carillon.

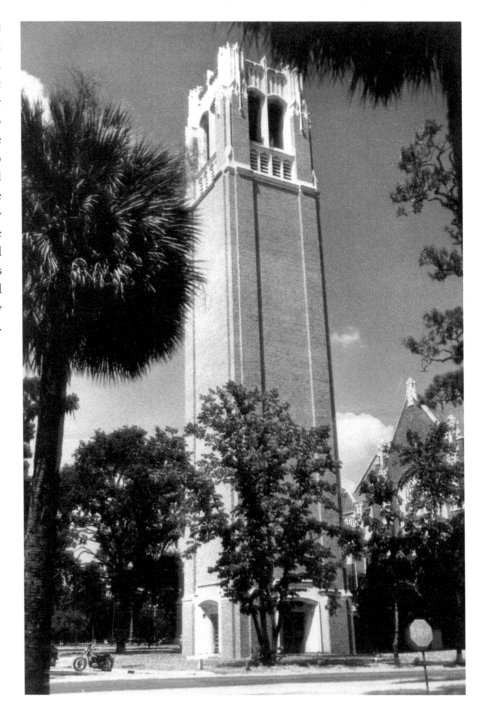

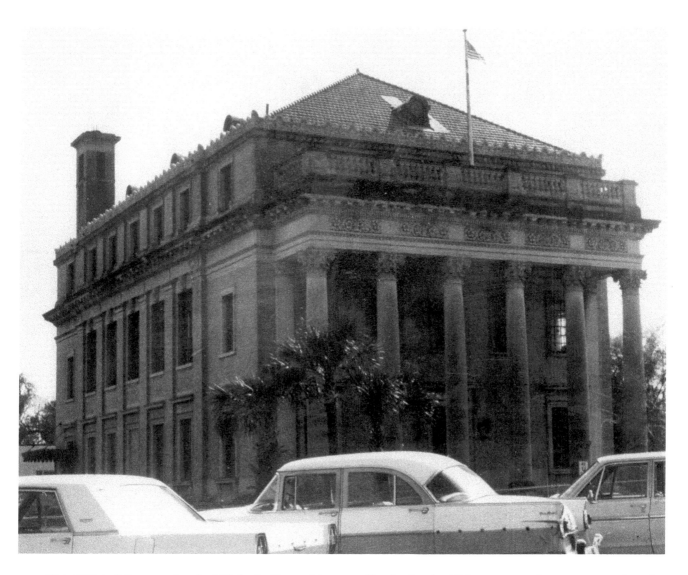

This 1911 building served as the U.S. land office and the post office for decades. Visitors were met by a monumental portico and six large columns supported by granite blocks, emphasizing strength and stability. Intricate scrollwork can still be seen just beneath the clay tile roof, and doors were covered with leather. Federal cases were tried in the courtroom on the second floor. In 1980, under the supervision of architect Al Dompe, the building was converted to use as the Hippodrome State Theater.

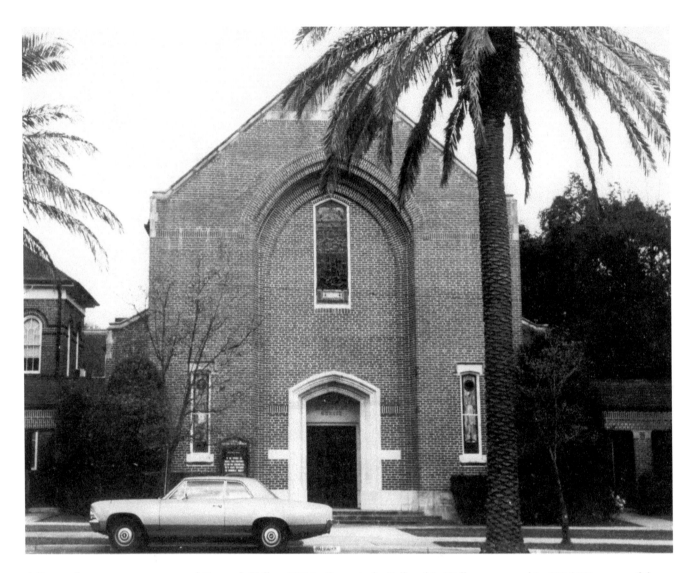

Adjacent the present sanctuary and Epworth Hall on NE 1st Street is the Fellowship Hall, constructed in 1886-87 as part of the Kavanaugh Methodist Church. Later known as the First Methodist Church, this building housed services for the congregation until 1942. The attractive brick building is now the church's venue for social events.

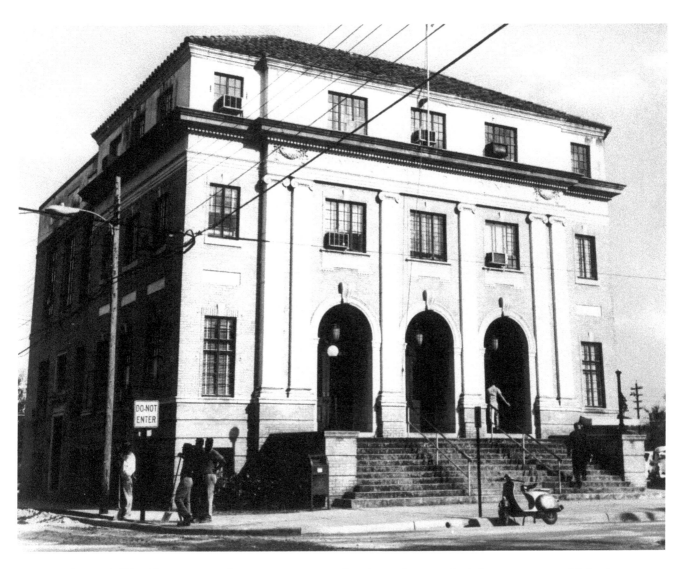

This city hall building was erected in 1927 to accommodate the newly reorganized city government, with its city manager and commission. The basement housed the police department. During the Great Depression, the building was rented to the federal Rural Resettlement Division, and municipal employees moved to other locations. In addition to rental income for the city, the federal employees brought a substantial payroll to Gainesville. This picture was taken in 1966, two years before the city hall was razed.

NOTES ON THE PHOTOGRAPHS

These notes, listed by page number, attempt to include all aspects known of the photographs. Each of the photographs is identified by the page number, a title or description, photographer and collection, archive, and call or box number when applicable. Although every attempt was made to collect all data, in some cases complete data may have been unavailable due to the age and condition of some of the photographs and records.

II BEACH
Florida State
Archives
c038648b

VI DUDLEY REED
Florida State
Archives
c018346

X INSURANCE
COMPANY
Florida State
Archives
n031236

2 CIVIL WAR SKETCH
Florida State
Archives
rc11534

3 LEONARD DENNIS
Florida State
Archives
pr01666

4 MEAT MARKET
Florida State
Archives
n031241

5 METHODIST
SOCIETY
Florida State
Archives
n031266

6 BUGGY
Florida State
Archives
pr03929

7 COURTHOUSE
Florida State
Archives
rc03364

8 HOME GUARD
Florida State
Archives
rc03365

9 COURTHOUSE
SQUARE
Florida State
Archives
pr03832

10 RAILROAD DEPOT
Florida State
Archives
rc06757

11 COURTHOUSE
SQUARE
Florida State
Archives
rc06073

12 GROUP OF GIRLS
Florida State
Archives
pr03910

13 NEW COURTHOUSE
Florida State
Archives
pr02171

14 GROCERY STORE
Florida State
Archives
pr03894

15 DAY SCHOOL
Florida State
Archives
rc06074

16 JEWELRY STORE
Florida State
Archives
pr03895

17 JOHN AMMONS
Florida State
Archives
rc06760

18 CATTLE HERDERS
Florida State
Archives
rc05578

19 STEAM POWER
Florida State
Archives
rc07980

20 BASEBALL
Florida State
Archives
rc06081

21 BLACKSMITH SHOP
Florida State
Archives
n031267

22 FIRE DEPARTMENT
Florida State
Archives
pr03878

23 LONELY HOUSE
Florida State
Archives
pr03900

24 PLANT SYSTEM
Florida State
Archives
rc08001

26 INTERRACIAL
BUSINESSES
Florida State
Archives
pr00855

27 WOODEN HOUSES
Florida State
Archives
rc06813

28 DR. PHILLIPS
Florida State
Archives
pr03921

29 FLORIDA SEMINARY
Florida State
Archives
pr03845

30 FOOTBALL TEAM
Florida State
Archives
n044027

31 ST. PATRICK'S
Florida State
Archives
pr03861

32 THOMAS HAILE
Florida State
Archives
pr08631

33 TEBEAU SCHOOL
Florida State
Archives
pr03901

34 **ELECTRIC AND GAS**
Florida State
Archives
pr038980

35 **UNIVERSITY AVENUE**
Florida State
Archives
pr03825

36 **CADETS**
Florida State
Archives
pr13099

37 **4-H CLUB**
Florida State
Archives
AG23212

38 **AGRICULTURE**
Florida State
Archives
AG23226

39 **CANNING SCHOOL**
Florida State
Archives
rc15516

40 **LAKE CITY**
Florida State
Archives
rc13663

41 **FAMILY IN FIELD**
Florida State
Archives
rc136683

42 **LOCOMOTIVE**
Florida State
Archives
pr09425

43 **FIRE DEPARTMENT**
Florida State
Archives
pr03880

44 **MOTOR FIRE ENGINES**
Florida State
Archives
pr03881

45 **UNION STREET**
Florida State
Archives
n031239

46 **ROWBOAT**
Florida State
Archives
pr03920

47 **HIGH SCHOOL**
Florida State
Archives
n031243

48 **EAST FLORIDA SEMINARY**
Florida State
Archives
pr03846

49 **McKENZIE HOUSE**
Florida State
Archives
pr03850

50 **UNIVERSITY BALL TEAM**
Florida State
Archives
pr00643

51 **HOLY TRINITY**
Florida State
Archives
pr03862

52 **FUNDRAISING**
Florida State
Archives
n031257

54 **EXPERIMENTS**
Florida State
Archives
rc13665

54 **ALACHUA AVENUE**
Florida State
Archives
rc06084

55 **FIREMEN AT WORK**
Florida State
Archives
pr03829

56 **GROCERY STORE**
Florida State
Archives
rc06141

57 **COURTHOUSE SQUARE**
Florida State
Archives
rc03366

58 **4-H CLUB**
Florida State
Archives
rc15015

59 **TRAIN DEPOT**
Florida State
Archives
pr13525

60 **COURTHOUSE SQUARE**
Florida State
Archives
rc06816

61 **MORRILL ACT**
Florida State
Archives
rc15608

62 **COURTHOUSE**
Florida State
Archives
rc03412

64 **CORNERSTONE CEREMONY**
Florida State
Archives
rc07056

65 **AUTO ACCIDENT**
Florida State
Archives
pr03942

66 **TIN CAN TOURIST CAMP**
Florida State
Archives
pr01242

67 **TIN CAN TOURISTS**
Florida State
Archives
pr01243

68 **PECAN TREE**
Florida State
Archives
rc17595a

69 **CREATING A LAKE**
Florida State
Archives
pr03835

70 **BAIRD HARDWARE**
Florida State
Archives
pr03818

71 **SPORTING GOODS**
pr03928

72 **LANGUAGE HALL**
Florida State
Archives
n044219

73 **THOMAS RESIDENCE**
Florida State
Archives
n031263

74 **COURTHOUSE SQUARE**
Florida State
Archives
rc06811

75 **TEA PARTY**
Florida State
Archives
rc13056

76 **FIRST SKYSCRAPER**
Florida State
Archives
rc06075

77 **BAIRD HARDWARE**
Florida State
Archives
pr03936

78 **AGRICULTURAL WEEK**
Florida State
Archives
AG23228

79 **CORN CLUB BOYS**
Florida State
Archives
AG23265

80 **13TH STREET**
Florida State
Archives
pr03948

81 **CONFEDERATE VETERANS**
Florida State
Archives
rc05874

82 **OGLETREE MOTORS**
Florida State
Archives
n06788

83 **KANAPAHA CHURCH**
Florida State
Archives
pr03822

84 **YOUNG WOMEN**
Florida State
Archives
n044215

85 **FIRST NATIONAL BANK**
Florida State
Archives
pr03885

86 **CYPRESS TREE**
Florida State
Archives
rc00-132

87 **DWARFED GROWTH**
Florida State
Archives
pr03947

88 **Tung Oil Float**
Florida State
Archives
rc05873

89 **Produce Store**
Aubrey Bullard
Collection Florida
State Archives
n046248

90 **Courthouse
Square**
Florida State
Archives
pr03893

91 **Seagle Building**
Florida State
Archives
pr03927

92 **Spanish Moss**
Florida State
Archives
n034676

93 **YMCA**
Florida State
Archives
pr13088

94 **Studying**
Florida State
Archives
lc392

96 **Kelley Hotel**
Florida State
Archives
n045866

97 **Airport**
Florida State
Archives
pr03810

98 **University**
Florida State
Archives
pr13103

99 **University
Avenue**
Florida State
Archives
pr03926

100 **Wave Tank**
Florida State
Archives
c672128b

101 **University
Avenue**
Florida State
Archives
pr03946

102 **Flavet Village**
Florida State
Archives
c005541

103 **Dry Goods Store**
Florida State
Archives
pr03883

104 **Beauty Contest**
Florida State
Archives
c004635

105 **West University
Avenue**
Florida State
Archives
pr03888

106 **Block and
Bridle Club**
Florida State
Archives
c005606

107 **Florida Farm**
Florida State
Archives
c011809

108 **Florida Field**
Florida State
Archives
rc10950

109 **Fraternity**
Florida State
Archives
ms26167

110 **Vertical Testing
Machine**
Florida State
Archives
c019384

111 **Southern Bell**
Florida State
Archives
rc20880

112 **Industrial Park**
Florida State
Archives
c033396

113 **Lawmakers**
Florida State
Archives
PT02095

114 **Recreation
Center**
Florida State
Archives
pr03960

115 **Glee Club**
Florida State
Archives
pr13101

116 **Storing Lumber**
Florida State
Archives
sp02287

117 **Museum**
Florida State
Archives
rc21193

118 **Solar Heat
Collector**
Florida State
Archives
rc17454

119 **Health Center**
Florida State
Archives
rc21174

120 **Newsman's
Seminar**
Florida State
Archives
c024952

121 **Memorial
Auditorium**
Florida State
Archives
rc10965

122 **University of
Florida**
Florida State
Archives
n044227

123 **Nancy Wakefield**
Florida State
Archives
c033407

124 **University
Avenue**
Florida State
Archives
c033393

125 **Experiment
Station**
Florida State
Archives
c032549

126 **Football Game**
Florida State
Archives
c037436

127 **Camping**
Florida State
Archives
c038613

128 **Century Tower**
Florida State
Archives
rc21169

129 **Post Office**
Florida State
Archives
pr03939

130 **Fellowship Hall**
Florida State
Archives
pr03941

131 **City Hall**
Florida State
Archives
pr03931

Printed in the USA
CPSIA information can be obtained
at www.ICGtesting.com
JSHW072024140824
68134JS00042B/3773

9 781683 368335